Acrylics for the
Absolute Beginner

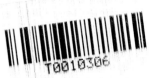

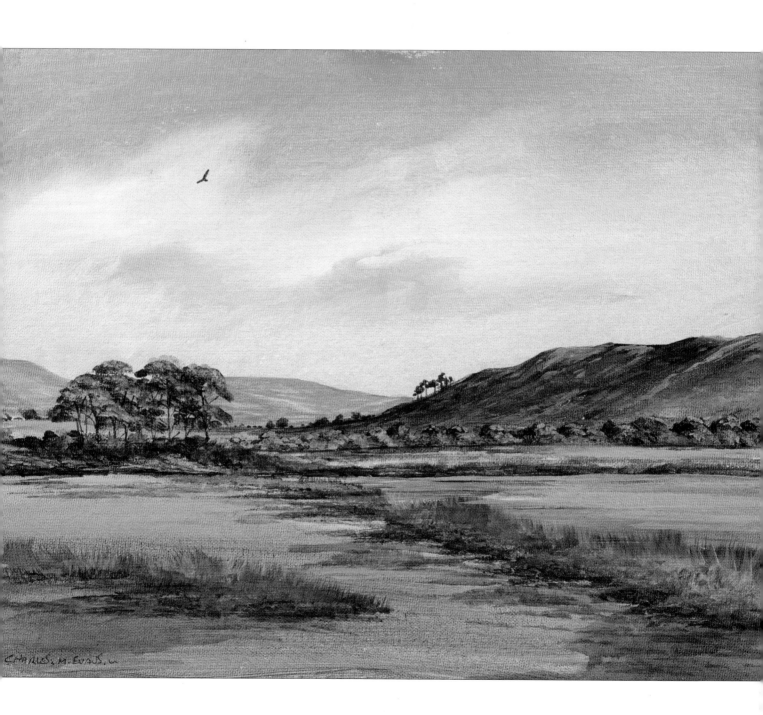

Dedication

This one is dedicated to Gail who organises my every move. I have no idea how, but she always seems to manage.

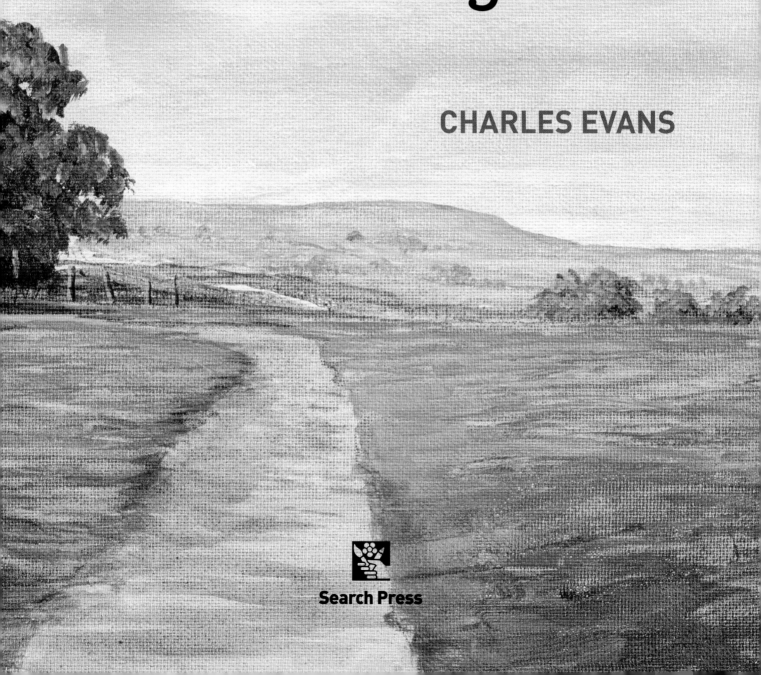

Acrylics for the
Absolute Beginner

CHARLES EVANS

Search Press

First published in Great Britain 2018

Search Press Limited
Wellwood, North Farm Road,
Tunbridge Wells, Kent TN2 3DR

Reprinted 2018, 2019, 2020 (twice), 2021, 2022 (twice)

Illustrations and text copyright
© Charles Evans 2018

Photographs by Paul Bricknell at
Search Press Studios

Photographs and design copyright
© Search Press Ltd. 2018

ISBN: 978-1-78221-398-7

Suppliers
If you have difficulty in obtaining any of the materials and equipment mentioned in this book, then please visit the Search Press website:
www.searchpress.com

You are invited to visit the author's website:
www.charlesevansart.com

Acknowledgements

I would like to thank Winsor & Newton for their continued support and supply of the most wonderful painting materials – every day is Christmas!

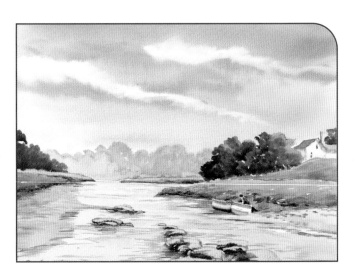

Page 1
Hillside Scene
A lone bird circling in the sky adds a little dynamism to contrast with the restful scene below.

Pages 2–3
Manor House
A great example of how you can lead the eye into a scene to create depth and distance.

Opposite
Woodland Walk
The path here leads the eye into the composition, with a red-jacketed dog walker as the focal point.

Contents

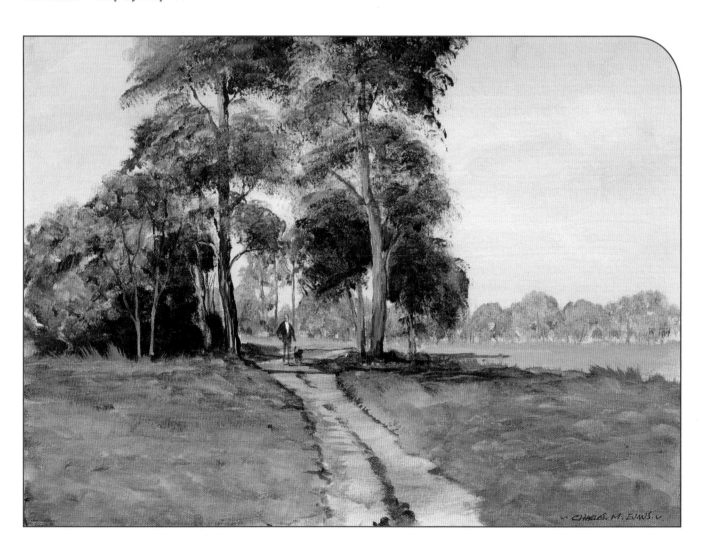

Introduction

The aims of this book are to demystify and to simplify the fabulous medium of acrylics. They have a bit of a reputation as being a little garish in colour and tone, but this is something that can easily be overcome by mixing and toning down. I have been painting with acrylics for many years and, over time, they have become my most-used medium when I am working in my studio.

Perhaps their greatest strength is their adaptability. I believe they are the most versatile of all the painting media – they can be painted onto canvas using techniques familiar to oil painters, or like watercolours on paper. People ask, 'why paint like watercolour on paper when you could just paint with watercolour?' The answer is that acrylics have the added advantage of being able to put light on top of dark, something impossible with traditional watercolour. When painting them on canvas they can be painted nice and thickly, but without the drying times of oil paints. In short, acrylics combine the best of both worlds, and have a few tricks of their own up their sleeves.

In this book, I shall take things right back to basics, so you will soon build up your confidence in the medium of acrylics. Starting with some simple techniques, we will work through to painting complete landscapes on both paper and canvas. Even the colour mixing is uncomplicated here, because of the smaller range of colours that we will use. You also need only a few brushes.

The most important part of any painting is to have fun and to enjoy the process. This comes with confidence and knowledge of the medium you are using. By the end of this book, your knowledge of this wonderful medium will certainly be greater than when you started, but perhaps more importantly, I hope you will have fun completing the projects within these pages.

Highland Croft
A classical strong foreground with recession created by the distant hills.

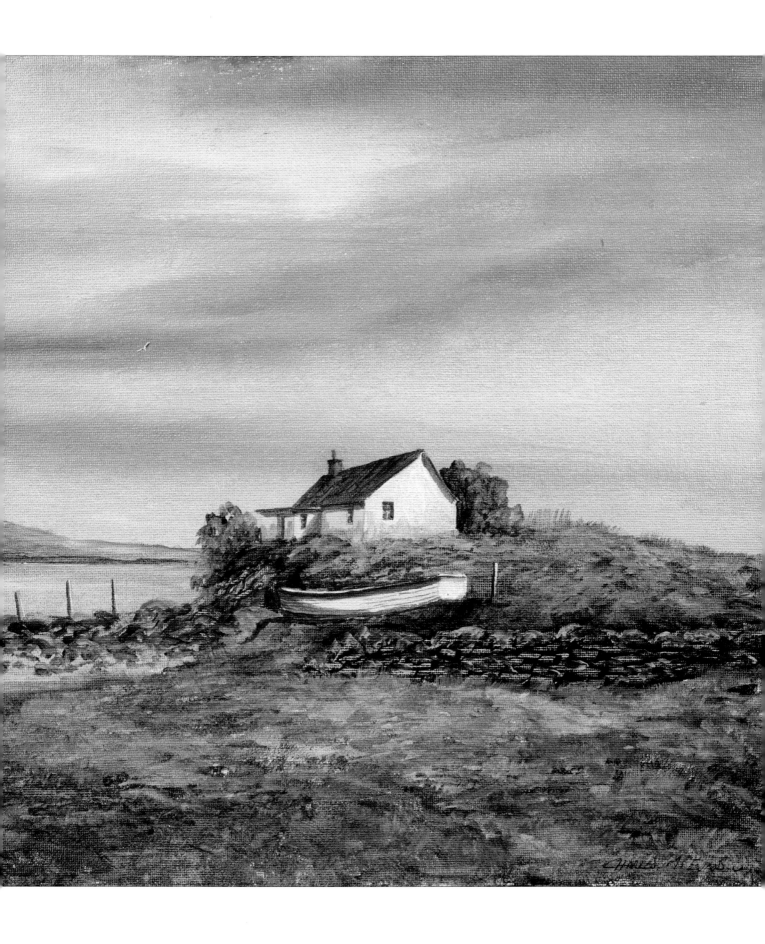

Materials

You don't need much to get started with acrylic painting. The following pages cover what I regard as the essentials, so you won't waste time and money buying things you don't need.

Paints

You don't need hundreds of paints. This small palette will let you mix any colour you need.

Payne's gray: This is a really nice dark colour with a hint of blue. Unlike manufactured black, this dark is not flat and 'dead'.

Permanent alizarin crimson: This versatile red has plenty of depth when used on its own, and is also a good mixer.

Burnt sienna: A lovely warm brown which is especially useful for adding a touch of realism to grasses and foliage.

Cobalt blue: I use this for so many skies as it is so easy to mix up or mix down creating different moods and skies.

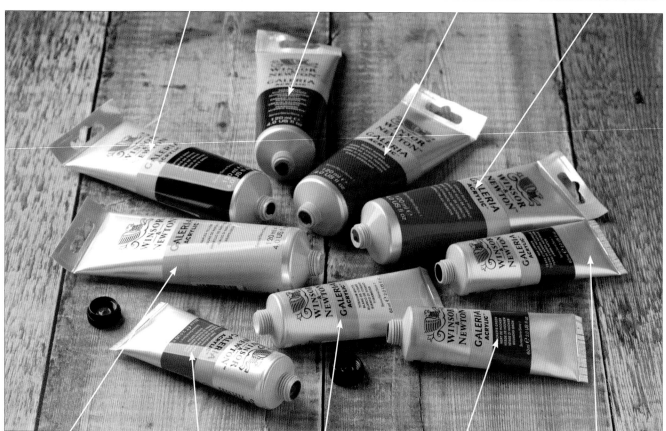

Naples yellow: When mixed with other colours, this is fabulous at lightening the tone without making things cold and chalky. It is especially effective at bringing life to foliage.

Raw sienna: I often use this to pre-stain canvases, leaving it to show through later washes. It adds a lovely glow to a painting.

Titanium white: There are many different whites available; I find it less confusing to stick with one. Titanium white is a good stand-alone white but also a good mixer.

Hooker's green: As a mixer, this fairly unnatural-looking green is fabulous – I can mix every colour in my palette into my Hooker's green and the result is a variety of wonderful, useful greens.

Raw umber: The only brown I carry. Add a touch of blue to it and I have sepia. Add a touch of burnt sienna to my sepia mix and I have Van Dyke brown. Combine raw umber and burnt sienna together and I have burnt umber – so useful!

Brushes

Brushes are available in different shapes. The two you need are round – the iconic tapered shape of an artist's paintbrush – and flat, which, with its chisel-shaped tip, looks a little like a tiny, elegant household brush. The shapes of the brushes affect how much paint they hold and the marks they make.

Galeria brushes, my preferred brand, are such useful and strong tools. With the few brushes listed to the right, I can achieve every effect I desire: the big flat for my expansive skies; the smaller flat for foliage and grasses; and the series of round brushes for both broad stroke and fine work as they retain a lovely point. As the bulk of the finer work is done with a size 8 round, this takes a lot of wear and tear, so I tend to have a back-up size 8 round with me.

Some of the variety of marks that each brush can make are shown below. If you use different brushes, look for similar qualities and make sure that you can produce the shapes below with them.

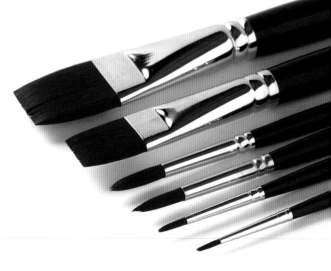

Top to bottom: size 20 flat, size 18 flat, two size 8 rounds, size 4 round, size 2 round.

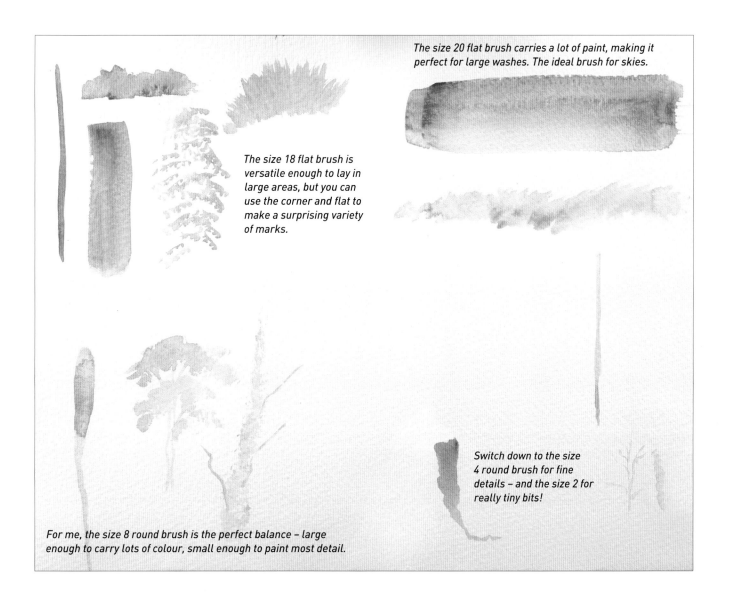

The size 20 flat brush carries a lot of paint, making it perfect for large washes. The ideal brush for skies.

The size 18 flat brush is versatile enough to lay in large areas, but you can use the corner and flat to make a surprising variety of marks.

Switch down to the size 4 round brush for fine details – and the size 2 for really tiny bits!

For me, the size 8 round brush is the perfect balance – large enough to carry lots of colour, small enough to paint most detail.

■ Painting surfaces

Once you have your paints and brushes, you need something on which to paint. One advantage of acrylics is that they can be painted on almost anything, but this book concentrates on the traditional surfaces of canvas and paper, which best suit the techniques we will explore.

Paper

Watercolour paper comes in a variety of weights and surface textures, which can be confusing at first. The paper I use is 300gsm (140lb) in weight, and has a Not surface (short for 'not hot-pressed'), which means it has a slight 'tooth', or texture. This paper is versatile and sturdy enough to carry lots of washes without affecting the surface, and there is no need to pre-stretch it, which makes it quick and easy to work with. You can buy watercolour paper in pads, blocks or separate sheets; whatever you choose is fine, as long as it is big enough – go for something 42 x 30cm (16½ x 11¾in) or larger.

Canvas

Canvases are available in many shapes and sizes and I take advantage of most of them. The surface is particular suitable for oil-style techniques, though the texture does make for interesting effects with the watercolour-style techniques. My preference is for Winsor & Newton's canvases, as they have a beautiful tooth and texture which allows me to slap the paint on thick and fast, and they are extremely hard-wearing. As with paper, choose a canvas 42 x 30cm (16½ x 11¾in) or larger.

Other materials

Pencil and eraser Almost any graphite pencil will be suitable for the basic outline which is all I am ever going to draw. In fact, I use the free ones you get when you visit certain home stores.

Water pot and hook It doesn't matter what kind of container you use for your water as long as it holds a large amount – I use a bucket. A hook is handy for hanging your water pot from your easel. Mine came from a clothes shop – after I asked very nicely!

Easel A metal easel is sturdier and easier to assemble out in the field than the flimsier wooden ones. It is a practical choice even if you are only working indoors.

Board I use a lightweight board because it is quite big. Larger boards can be fairly weighty, so choose carefully.

Bulldog clips These are particularly useful and always clipped to my board. As I take the tape off a finished painting, I then slip the paper underneath the bulldog clips.

Masking tape This is used to hold your paper to your board. I recommend a wide, low-tack masking tape, to hold the paper securely, while avoiding the risk of taking the surface off the paper when you remove it.

Stay-wet palette and refills There are many variations of a stay-wet palette, almost all of which come with refills. The two important factors are always to make sure they have a lid and are big enough to mix colours in as well as holding your pure paint.

Painting smock I'm in the fortunate position of having my smocks – basic coveralls – provided for me by Winsor & Newton. As with the rest of my materials, my smock is hardwearing and helps to keep the wind out when standing in the middle of a field.

Plastic card Any old plastic card will do. For me it always depends on which hotel I am staying in at the time as to which keycard I end up using.

Tip
It may not be strictly essential, but I always find a glass of red wine makes the whole painting experience very enjoyable!

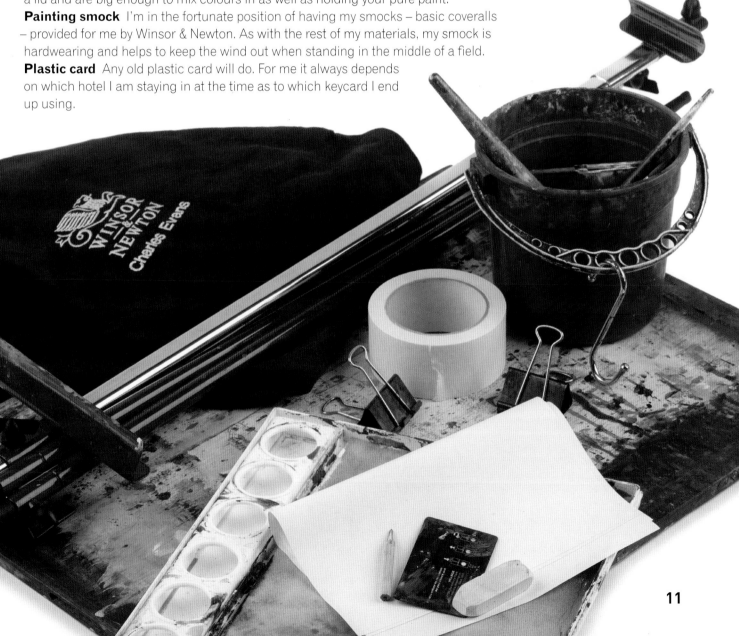

11

Painting successful pictures

We all want to create artworks that look good and catch the viewer's eye. Over the following pages I'll walk you through some hints and tips for composing a striking image – that is, working out what to include and where it should go on the surface – and for getting the best results in your painting.

Drawing: keep things clean

I never labour with a sketch which is going to be made into a painting. All you need is a basic outline of the main shapes – there is no need to suggest any tone with shading. In fact, the less drawing you can do, the better: wet paint will smudge and smear any heavy pencil work. This is especially noticeable with white paint, which will develop a murky grey hue. In general, the lighter your work, and the fewer pencil marks you make, the lower the chance you have of making smudges.

With that said, having some light guidelines to help you get the paint in the right places is useful, and a good simple drawing will make the painting process more relaxing and enjoyable. Look for the main shapes: a good place to start is the horizon, or a particularly eye-catching main feature. Depending on what you are painting, this might be a figure, a hillside or a building. Use a light touch of the pencil to draw the outline of the object in, then place other objects in relation to it. Once you feel you have enough information to get started, put the pencil down and begin to paint.

A preliminary drawing

This drawing was made for the painting opposite. I started by adding the horizon line, then added the hills and line of the shore. With the hills in place, it was easier to work out where the boats would go.

Next, I used an eraser to clean up by removing unnecessary lines – such as the horizon line on the left, where it is hidden by the hills.

Note that the sky and sea are left blank. The interest and texture in these is best applied with paint.

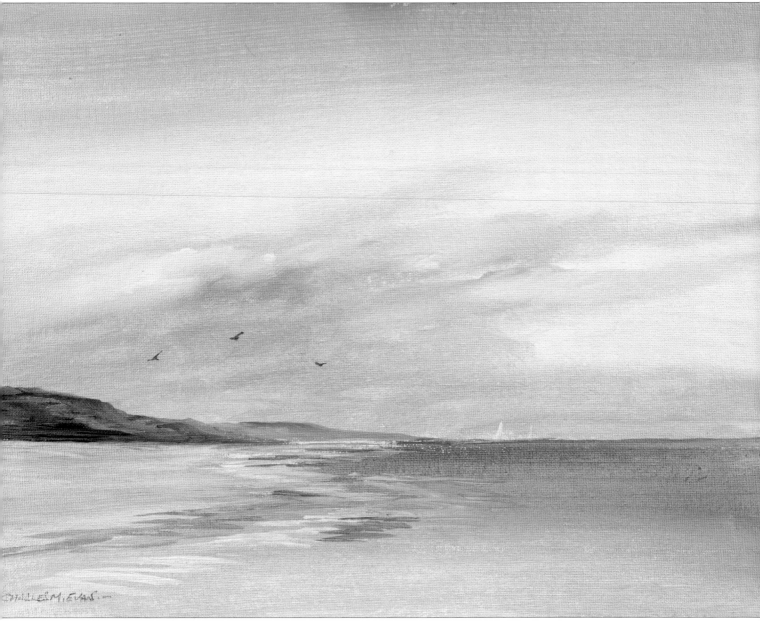

Druridge Bay

This is a very simple painting, based on a view I know very well as the beach lies just two miles from my home. The large sky creates a relaxing atmosphere; having no pencil lines in this area allows you to decide between a fresh cloudless sky, dramatic clouds, or – like this painting – something in between, without worrying about smearing the graphite and muddying your paint.

Using photographs

Photographs can be both helpful and counter-productive when trying to compose your painting. They are a great way to gather lots of information about a scene that you like, freezing it in time so you can study it in detail. However, sometimes a photograph can provide too much information, making what caught your imagination seem daunting and over-complicated.

Secondly, there is always the temptation to stick to the image itself too rigidly, instead of using your artistic judgement to adjust it – or, in other words, getting rid of what you don't want and don't need.

The hints and tips here will give you some pointers on how to use photographs effectively to help your painting.

- When taking photographs, it is not necessarily important to get a technically perfect image, but make sure that you capture what initially caught your eye and attracted you to the scene.

- When drawing from a photograph, keep things simple. As for anything else, draw the main shapes and rely on painting for the details. There is an example of how to do this on pages 16–17.

- When painting from a photograph, do not try to copy the colours from a print or screen – instead, try to remember them from life. Make supporting notes on site, if possible.

- Try selecting just a section of the image, cropping out extraneous detail.

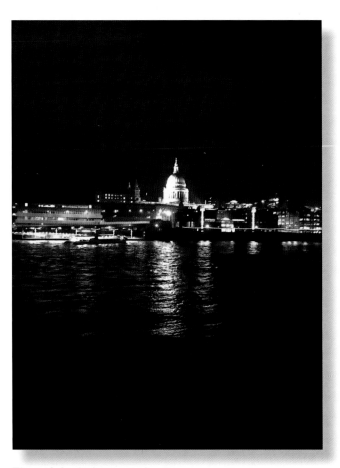

The original photograph

This is a photograph I took on my mobile phone, whilst standing outside the Royal Watercolour Society at the Bankside Gallery in London. I particularly liked the way the cathedral and edges of the buildings around it were illuminated by the huge floodlights.

It is not a technically perfect photograph – I had enjoyed a few glasses of red when I took it, and am not particularly good with technology at the best of times! – but it does the job I needed, which was to capture the character of the scene and to give me plenty of information with which to construct the painting.

Cropping

Before I used the photograph, I cropped it down slightly to get rid of any information I didn't want. By cropping out the extra space around the edges, the focus is placed on the main element of the cathedral and the buildings around it captured the light beautifully.

St Paul's Cathedral

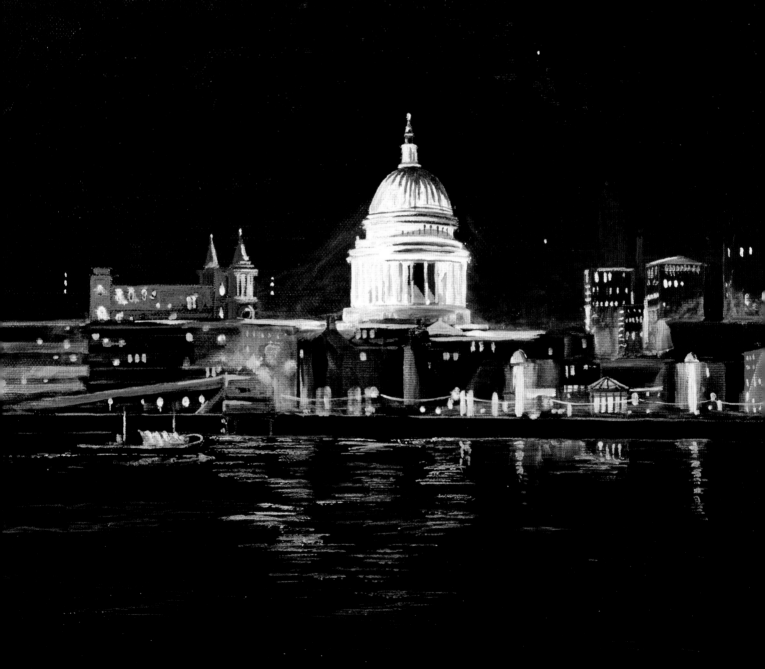

CHARLES. M. EVANS

Simplifying

When drawing out the shapes, remember that it is perfectly fine to move people or trees within your composition, or even cut them out of the image completely, as long as you keep the essential information to make it look like what it's supposed to be.

In this drawing made from a photograph of the White Cliffs of Dover, for example, I have missed out an entire town near the centre of the picture. It added nothing to the composition, since the suggestion of distant buildings is already present on the left (though even these are simplified), and it would have distracted from what I really wanted to show – the distinctive and characterful chalk cliffs.

I have added some notes to the drawing on the opposite page which will explain the sorts of decisions I make when simplifying a photograph.

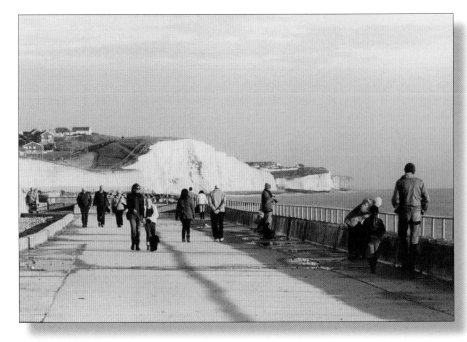

The original photograph

I have reduced the detail in the background settlement – too much 'busyness' here will draw the eye and be distracting.

The edge of the cliff face is stated, but none of the texture of the cliff is included – this will be added with paint, later.

The sky is left completely clear – pencil lines here can be smudged and smeared by paint, so keep things clean.

The distant town wouldn't add anything to the painting, so I've done a little 'town planning' and removed it from my drawing.

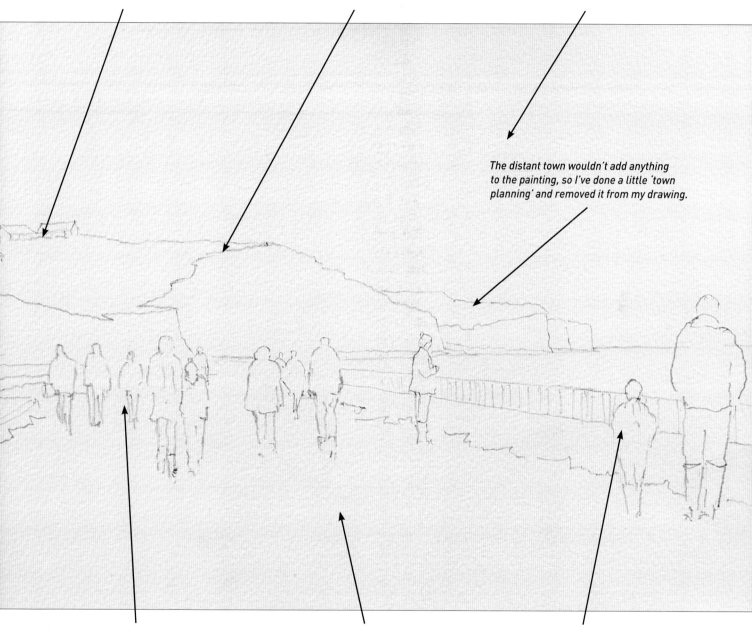

The crowd in the midground is broken down into a few small groups, none of which is drawn in great detail.

The foreground is left as a blank area for paint – none of the light and shadow is included, just the edges to help guide me.

These foreground figures have more detail included. Being so close to the edge, they prevent the eye wandering off. Note that I have not included the third figure, which would have confused and over-complicated the simple shapes.

From photograph to painting

These pages show an example of what we have been talking about on the previous pages; turning a promising photograph into a simplified drawing, and then into a finished painting.

As I made the drawing, I wanted to make sure that the building itself stood out, so I moved the trees about. The largest tree is reduced in size so that it frames the distant part of the building, while the tree on the right has been removed entirely.

The small tree in front of the building has been further reduced in size and straightened a little. The shadow it casts now highlights and draws attention to the building, rather than hiding it.

I added a grassy verge on the left-hand side, and a shadow creeping in at the bottom right. These elements help to frame the painting and lead the eye into the picture.

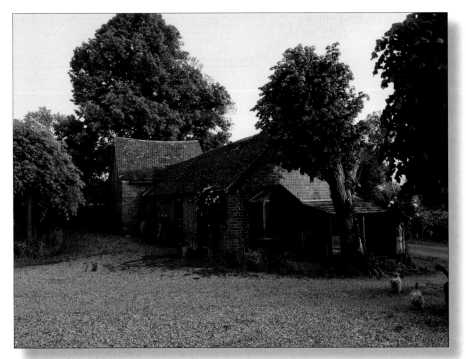

The original photograph

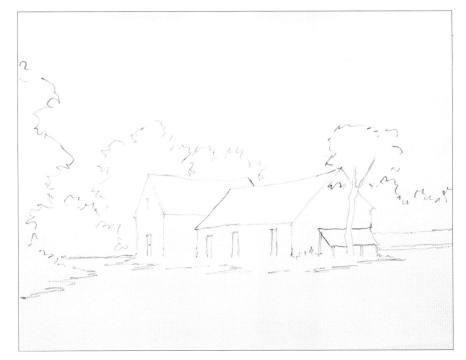

The drawing made from the photograph.

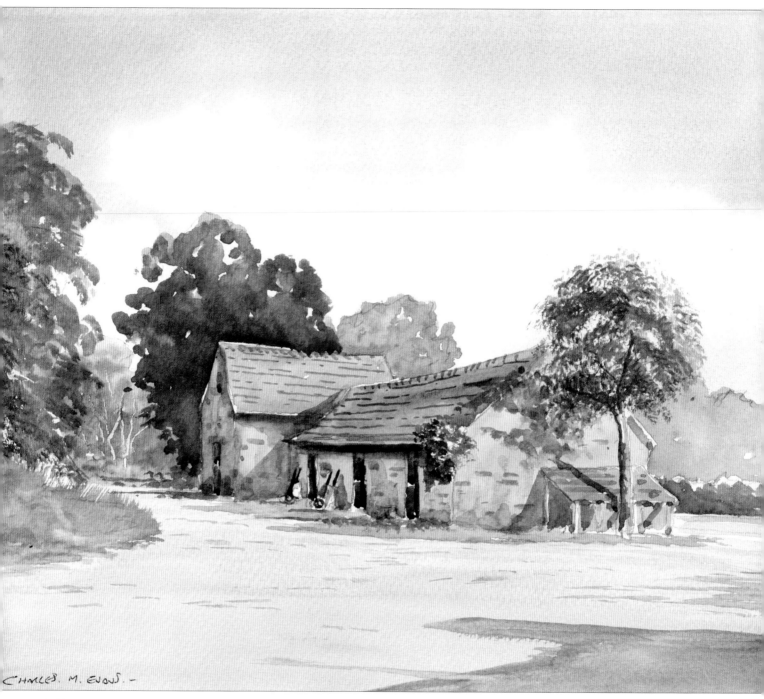

Suffolk Barn

*Compare the finished painting with the photograph opposite, and you will see where I have stuck closely
to the original, and where I have applied some artistic licence to make a better composition.*

Depth and distance

Getting a sense of perspective into your paintings is a good way to make them more effective. Creating the impression that some areas or objects are more distant than others relies on the colour and amount of detail you use to paint them.

More distant objects tend to appear more blue-grey than objects closer to the viewer (due to particles in the atmosphere), so we can use cooler (bluer) paints in our mixes for distant areas. In addition, the further away something is, the less detail you will be able to see. Using more dilute mixes will encourage paints to blend, which is useful for distant areas. Similarly, painting close objects with strong, clear marks and warmer, drier mixes, will make them look closer to the viewer.

The exercise will lead you through painting a simple landscape that demonstrates the principles.

Background tree

1 With a wash of blue in place as a basic sky (see page 40 for guidance on painting a more interesting one if you prefer), add a distant tree – don't fiddle about with detail, either in tone or structure. This is a long way off. Just drop it on, (preferably while your sky is still wet) using a mix of Hooker's green and burnt sienna. That way you will get a little bit of spreading and softening in the paint, giving a hazy indistinct result. Add cobalt blue wet in wet on the shaded side.

Midground tree

2 The midground tree has slightly more detail, so use a size 8 round brush to create the shape of the trunk and main branches. Being closer, it appears larger, too. We use the same mix of paint, but with less water. This gives a stronger, clearer result. At this distance, we need to anchor the tree with a little patch of grass beneath it.

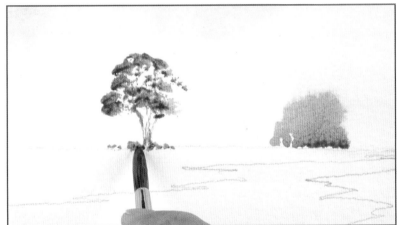

Foreground tree

3 Use a mix of raw umber with Payne's gray for the strong dark trunk and branches of the foreground tree. Being further forward, you need to add detail to make it look a little more complex. Use Payne's gray on the right-hand side and Naples yellow on the left for shadows and highlights respectively. The Hooker's green and burnt sienna mix used here is very strong, and larger marks are used for the foliage. Note that the grass beneath the tree is also larger.

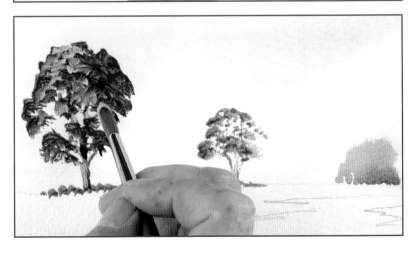

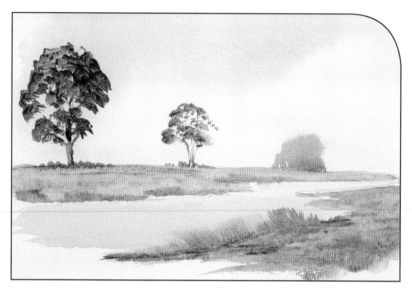

Finishing the landscape

Trees are part of the landscape, so don't think of them in isolation. Use raw sienna beneath the distant tree, but strengthen the colour beneath the foreground tree by adding Hooker's green to raw sienna. A little Payne's gray is added on the bank. The river itself is cobalt blue and Payne's gray, with more water added further into the distance. The foreground grasses are built up with strong brushstrokes to suggest texture, while those in the distance are softer.

Winter Walk

The same principles apply here, in this wintry scene. Compare the way I have approached the various trees in the painting. Which use stronger tones? Which have more detail? In addition to suggesting distance with the way I have painted the trees, the man and his dog have left a trail of footprints. Starting relatively large near the bottom of the painting, the marks I have used to describe them have got gradually smaller as the figures have gone further into the distance.

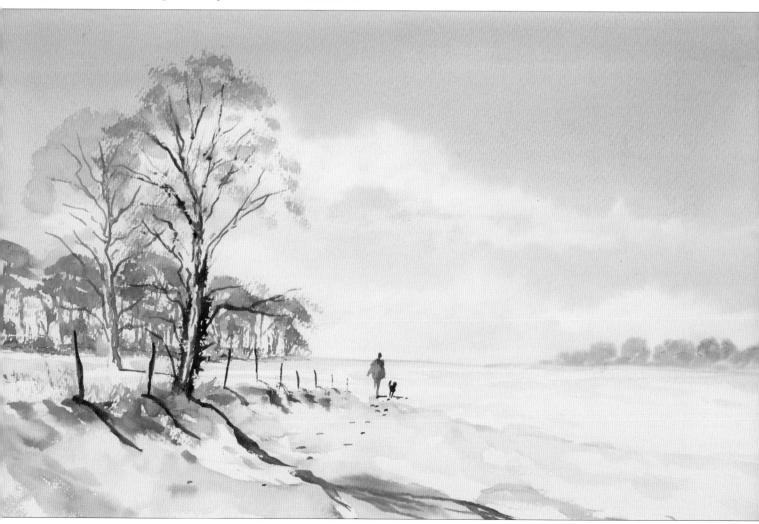

Light and shade

It may sound strange but if you want to get plenty of light in a painting, you should include lots of dark areas. It is contrast in tone – the relative lightness or darkness of a colour – that will make for striking, effective paintings.

The term for placing areas of high tonal contrast next to each other in a painting is called counterbalance. It is often misunderstood but you just need to make sure that dark areas are bordered by light areas, and vice versa. For example, you make sure that light-toned distant hills are placed underneath the darkest area of your sky, while darker ground sits underneath light-coloured clouds, thereby providing a counterbalance between the sky and ground.

The painting on this page, for example, is enhanced by the strong lights and strong darks contrasting with each other. The white building is set amidst very dark trees. This is an example of counterbalance, as is the patch of very dark trees on the opposite side, sitting on top of an area of light ground.

Of course, while this is a useful tool, you don't have to apply the principle everywhere – you might want softer contrasts in order to create a harmonious, calming effect. An example of that here is how the grass, sandy bank and water in the lower left-hand corner blend into one another, so that the focus goes to the boat.

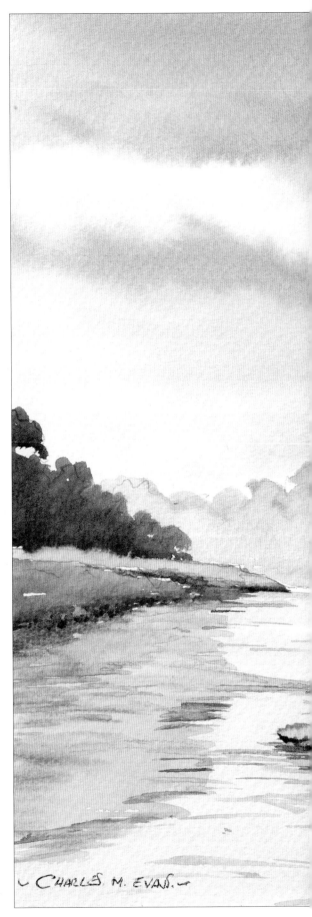

Seaton Sluice

A place fairly close to my home in Northumberland, UK, this always makes for a lovely painting. The quality of the light here means it offers endless inspiration, whatever the season.

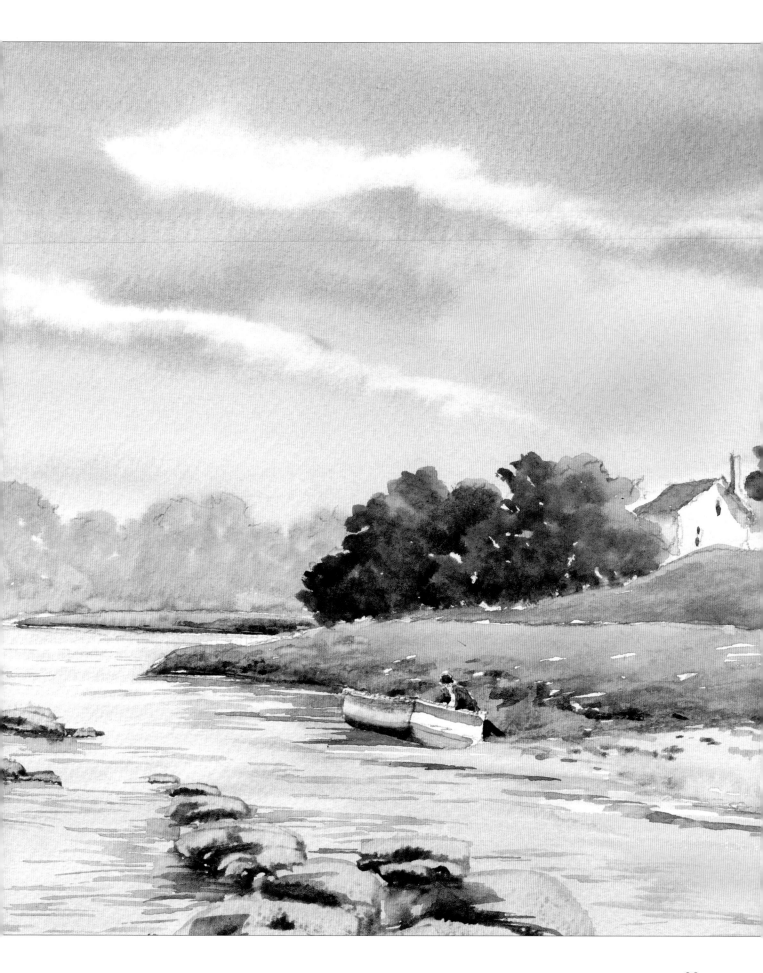

Getting started

Now we can get started with the business of painting – and don't be scared of the medium. Acrylics are possibly the most forgiving type of paint avilable, and we are building up from basic, simple stuff. Let's start by simply slapping some paint on together!

The colour palette

It has taken me many years to whittle my palette down to the few colours that I use regularly (see page 8), but I have found, through necessity and trial and error, that with these few I can mix any colour I want for wherever I am in the world. As a result, I don't need to alter my colour palette for differing subjects or different landscapes – and you won't need to either, for the exercise and projects in this book.

 All of the colours that I use are essential to my particular way of painting but there are some alternatives. For instance, yellow ochre can be used as a substitute for raw sienna in most cases. There are myriad whites available, just as there are many different browns. But to me, none of them are as useful as the colours that I use.

 Not every colour will be used for every painting, and the amount you need will vary – you'll use more Hooker's green in a forest scene than you will in a sunset seascape, for example. Decide which paints you want to use in a painting before you begin. For the projects in this book, I have listed the ones you need at the start.

Laying out your palette

I use a stay-wet palette, which is a plastic tray with a sponge in. You wet the sponge and lay a piece of stay-wet refill paper on top. This is a semi-permeable surface that lets a little of the water through, which keeps the paint moist and useable for days and days. This means that you can squeeze out generous amounts of paint onto the surface without fear of wasting it, which in turn means you can make large quantities of each mix so you don't run out of a particular one halfway through a painting.

 Once I have chosen the particular colours I will use for a painting (see above), here's how I lay out my palette.

1 Thoroughly wet your stay-wet refill paper and place it on the wet sponge in your palette.

2 Pick up your first paint and squeeze the amount you need onto the palette – there's no need to be mean, but equally no reason to waste it.

3 Leaving a little space between each one, squeeze out the other colours you need for your painting. Place each pool of paint near the edge, and leave an area in the centre for mixing colours together.

Mixing colours

Mixing colours is as simple as picking them up and combining them on a clean area of your palette. Depending on the amount of the mix you need, you may need to take more than one brushful of each colour. It is good practice to rinse your brush between colours.

1 Wet your brush and dip it into the pool of your first paint to pick up some of the colour.

2 Take the paint to a clean area of your palette and wipe the brush on the palette surface (see inset) to transfer the paint. Rinse your brush, then pick up your second colour.

3 Take the loaded brush to the first colour and mix the paints thoroughly on the palette.

Useful mixes

A virtue of using so few colours in my basic palette is that I have become familiar with how they all combine, and learned to mix so many different hues and shades of existing colours to suit every occasion. The following mixes will be useful additions to your repertoire.

Earthy brown made up of raw umber and cobalt blue.

Warm brown made up of raw umber and burnt sienna.

Dark grey made up of raw umber and Payne's gray.

Neutral mixes

It's easy to mix mud by mistake, but interesting neutral colours – those made by combining primary and secondary colours – are worth looking at. They provide important contrast to brighter colours and add realism to your work. The mixes here aren't glamorous, but are useful to know as they will add realism to your work.

Green mixes

A lot of beginners struggle with greens, but there's no need to worry. The examples on this page show a few of my favourite green mixes, though there are many more. Spend a little time practising mixing some up, and record which ones you found useful.

You will notice that the mixes here all involve Hooker's green. Although it appears fairly synthetic and unnatural on its own, Hooker's green is a very versatile mixer. When combined with the other colours in your palette, you can create a huge range of organic, naturalistic greens that can be used for a large variety of tasks in your painting. On top of that, because all of the mixes are based on the same colour, it all sits in harmony in the painting.

Hooker's green and burnt sienna make a lovely mid to dark green for some of the darks in your foliage.

A mix of Hooker's green and raw sienna combine to make a reddy-green, perfect for dry or winter grasses.

Hooker's green and Naples yellow, a nice shade of green for lighter trees and luscious grasses.

Hooker's green and raw umber is a good dark mix that works well for stronger foliage, particularly in the foreground.

Hooker's green and alizarin crimson, another smashing dark green. If you mix these in equal quantities, you can make an effective black.

Hooker's green and Payne's gray combine to make a cracking blue-green, suitable for poplars and conifers.

Using the brushes: a simple tree

There's no better way to practise mixing greens and neutral hues than to paint a tree. Follow this step-by-step to get used to creating mixes of paint at the right consistency and applying them to the surface, as well as learning the characteristics of the brushes. We are painting on paper here, but the same approach will work on canvas just as well.

You will need your size 8 round brush and a size 18 flat brush. A flat brush is such a useful brush – it provides versatility, offering broad strokes with the flat and edge, but also allowing you to add detail with the corner and blade.

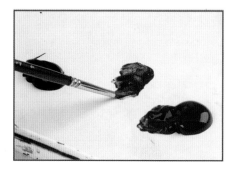

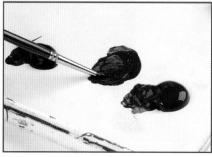

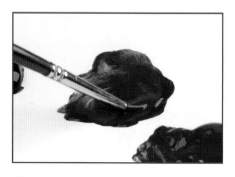

1 The first thing we need to do is paint the structure of the tree, so we use a mix of raw umber with a touch of Payne's gray for the bark. Mix this with the brush you will be painting with – the size 8 round brush. Pick up the first colour – with acrylics which one is first doesn't matter – and place a little on a clean area of the palette. Here this first colour is raw umber.

2 Pick up the next colour – Payne's gray – and add it to the same area, mixing it thoroughly on the surface.

3 Add clean water to dilute it to a creamy consistency, then load the brush by dipping it into the mix on the palette. Fill the brush right up to the ferrule to make sure you have plenty of the paint on the bristles.

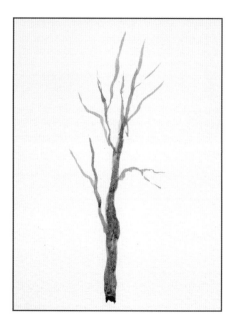

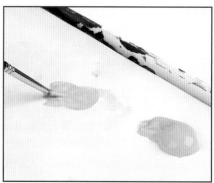

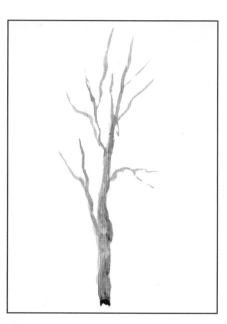

4 Paint the basic structure of the tree with simple lines as shown, then clean your brush.

5 For preparing single colours, the process is the same as for mixing – you take the colour from the squeezed-out swatch and transfer it to a clean space on your palette before adding water there, and loading your brush from here. This keeps the original swatches clean while ensuring you water your paint down to the right consistency. Prepare the Naples yellow, adding water until it feels creamy.

6 Add touches of the Naples yellow to the tree to create texture and interest, concentrating on the left-hand side.

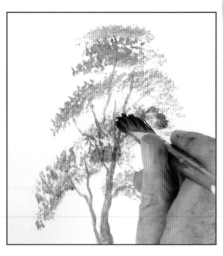

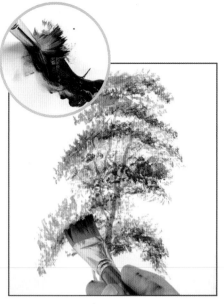

7 Mix Hooker's green and burnt sienna with the size 18 flat brush – don't add any water to this; keep the consistency thick. Once you've mixed the colour, stab the tip of the brush straight down into the mix so that the bristles fan out. This is called 'splitting the brush'.

8 Keeping the brush straight on to the surface, gently tap the split ends of the brush onto the surface. This will create an interesting effect that works well for building up foliage quickly. Tapping the paint repeatedly onto the surface in this way is called stippling.

9 You can continue overlaying other colours on top – prepare some Payne's gray and stipple it on lightly for shading near the bottom of each area of foliage.

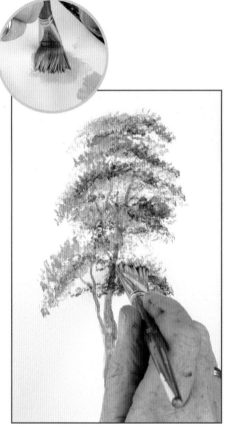

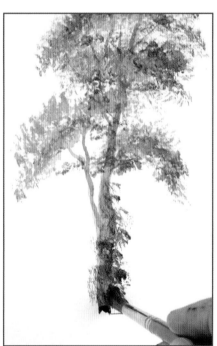

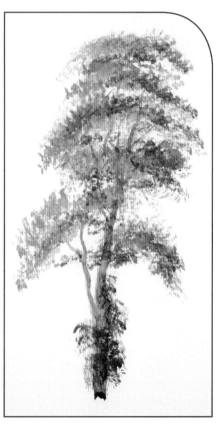

10 Prepare Naples yellow and stipple it on lightly as highlights – these are added to the top of each area of foliage.

11 Make another green mix (see step 7), using the same colours, but add some Payne's gray this time. Split the size 8 round (just as with the size 18 flat) in this mix. Gently stipple the trunk of the tree to suggest ivy on the base to finish.

The finished tree

Fine marks and stippling: seasonal trees

Trees change through the year, and not just in colour. This section shows you a few of the crucial changes to get trees looking right for your paintings, whatever the season.

This exercise builds on the split brush and stippling techniques, which are used to create the effect of foliage quickly and simply. To do this, you simply load a flat brush with paint by pressing it straight down into the mix on your palette, as shown to the right. The bristles will splay out, and can then be 'tapped' straight down onto the surface to create a series of loose, random mark. This downwards tapping technique is called stippling.

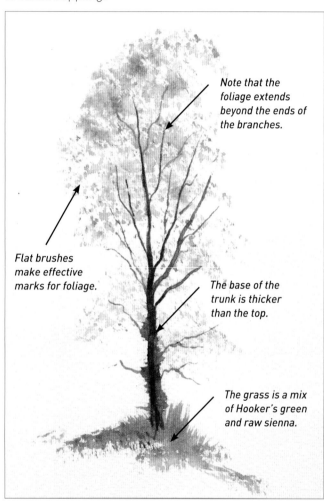

Note that the foliage extends beyond the ends of the branches.

Flat brushes make effective marks for foliage.

The base of the trunk is thicker than the top.

The grass is a mix of Hooker's green and raw sienna.

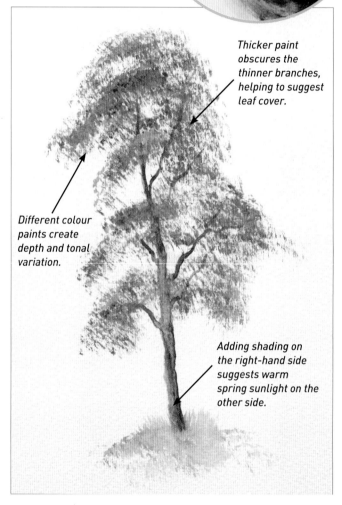

Thicker paint obscures the thinner branches, helping to suggest leaf cover.

Different colour paints create depth and tonal variation.

Adding shading on the right-hand side suggests warm spring sunlight on the other side.

Winter

With little foliage, winter trees are very simple to paint, and a good starting point. Using a size 4 round brush loaded with Payne's gray, start at the base of the tree and work upwards to create the trunk. Press the brush down at the bottom, and lift the brush off slightly as you work upwards to gradually taper the brushstroke off and make a narrowing line. Add the smaller branches using the tip of the brush and the same colour.

Add more water into the Payne's gray, then load your size 18 flat brush with this mix and with the flat of the brush simply tap on to create the canopy.

Spring

The same brush and techniques used for the winter tree are used for the trunk and branches, but this time raw sienna is used in place of Payne's gray. Add a mix of raw umber with a touch of cobalt blue into the paint for the darker side.

With the same flat brush as in the winter tree (size 18), I split the brush and stippled a fairly strong mix of Hooker's green and raw sienna to create the foliage. Once that was in place, I repeated the split brush stippling in some of the green areas using pure raw sienna to add areas that were catching the light.

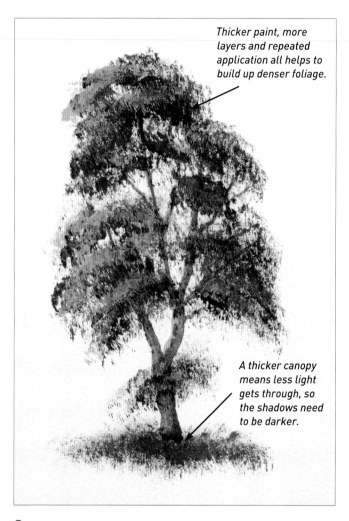

Thicker paint, more layers and repeated application all helps to build up denser foliage.

A thicker canopy means less light gets through, so the shadows need to be darker.

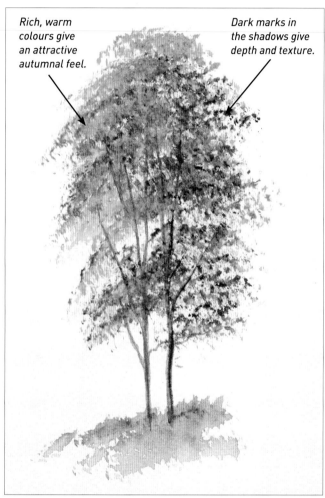

Rich, warm colours give an attractive autumnal feel.

Dark marks in the shadows give depth and texture.

Summer

Summer is when the trees are densely covered with mature foliage, which has darkened as the year heats up. As before, use the same processes and brushes, but the colours used need to be a little stronger in order to increase the coverage.

For the bulk of the foliage, use a mix of Hooker's green and burnt sienna, and stipple on a little raw sienna here and there for light. When applying the initial foliage, don't use more pressure to apply the paint, as this will give unattractive blobs. Instead, simply spend more time stippling lightly, and let the texture build up gradually.

Autumn

The warm reds and browns of autumn make a dramatic difference to the appearance of the tree, but in terms of techniques, much the same approach can be taken.

Build up the trunk and foliage as for the spring tree, substituting raw sienna in place of the green mix. With the raw sienna in place, stipple on burnt sienna and then a little Payne's gray for variety in the darks in the foliage. Note that the tree is not as densely covered in leaves as the summer tree – some have already fallen as the tree begins to return to its bare winter appearance.

Figures

If you want to add figures to a landscape, make your figures small. There are two common faults – making the heads too big, or the legs too short.

If you can write letters, you can paint people. Use a size 4 round brush to write 'Y P.' on your paper, as shown to the right. If you can do that, you can paint figures – just follow the step-by-step below!

The colours I suggest in this exercise can be swapped out for any you like – after all, we don't all wear the same clothes. With that said, bright colours work best for tops, while more muted colours, like cobalt blue or a neutral mix (see page 26) work well for trousers.

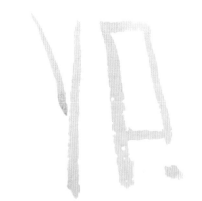

These two letters are the key to this quick and easy way to paint distant figures.

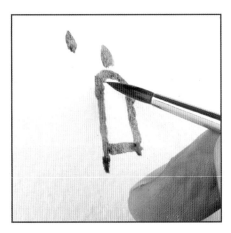

1 Use your size 4 round brush to paint two dots on your paper using dilute cobalt blue. Using a different colour – alizarin crimson here – put a P shape beneath one dot.

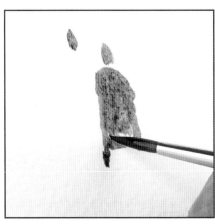

2 Fill in the hole of the P to make the top half of one figure.

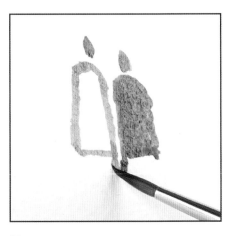

3 Add a P facing the other way beneath the other dot using a different colour (Hooker's green here).

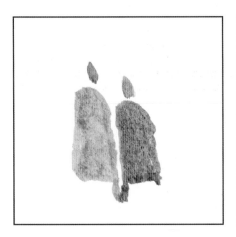

4 Fill in the other P as before, to add the top half of the second figure.

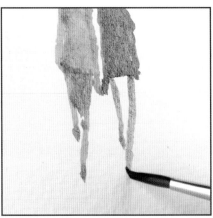

5 Add a Y shape beneath each top as legs using cobalt blue, then fill in the space on each.

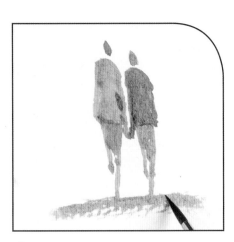

6 Anchor the figures to the ground with a little shadow using the same dilute cobalt blue to finish.

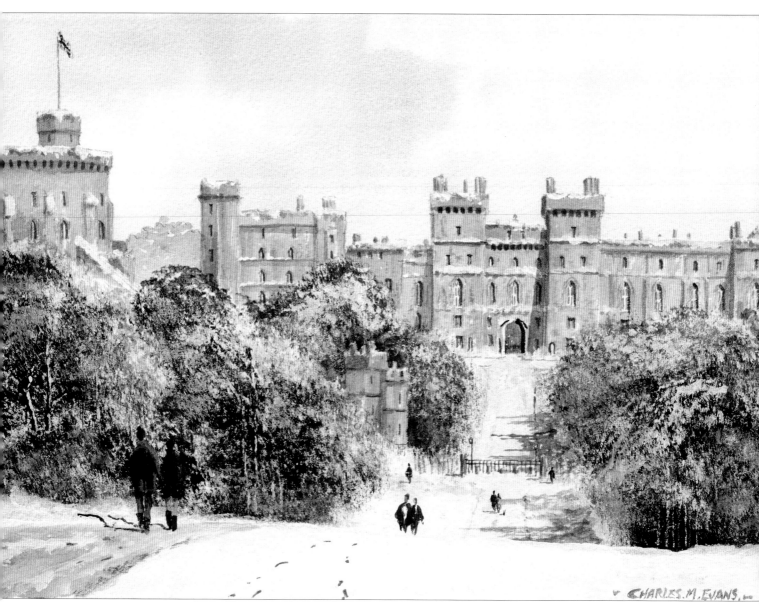

Windsor Castle

The castle would be striking and impressive on its own, but notice how the figures add some hints of eye-catching bright colour. These seemingly minor additions to the painting help to enhance the overall composition by suggesting the scale of the building and leading the eye into the painting.

Tip

Your figures can be joined by a dog – simply draw a square near the ground, then add a few short strokes for the legs, tail and head.

Animals in the landscape

Adding livestock to your paintings can give a landscape a little more life. As with figures, make these small so they don't dominate the image. When painting a herd of any animals, vary the direction they're facing.

Tip

If you want animals to take a more central role in your paintings, the chapter on pages 112–127 will give you some more details.

Sheep

1 Use an HB pencil to draw a small shape; a little like a loaf of bread.

2 Add an additional lump on one end as shown.

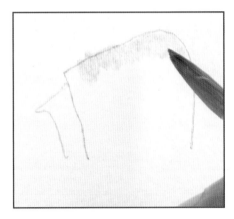

3 Use very dilute raw sienna to paint the top with the size 8 round brush.

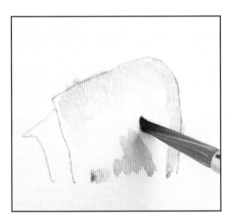

4 Add dilute Payne's gray down the side, and an inverted V beneath.

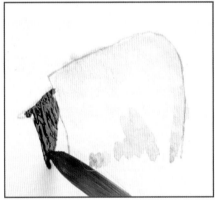

5 Use strong Payne's gray to add a little detail for the head.

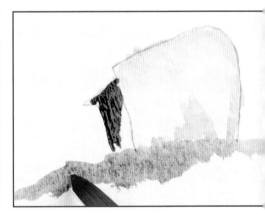

6 Add a line of grass using a green mix (see page 27 for some options).

Cow

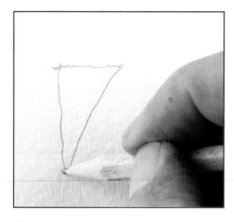 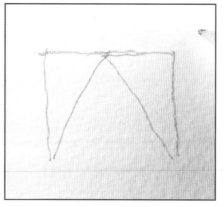

1 Use an HB pencil to draw a small triangle.

2 Add a second on the other side.

3 Add two smaller triangles on the right-hand side, then connect the two large triangles – the shape of the cow suddenly appears!

4 Use the size 8 round brush to start adding some markings using fairly strong Payne's gray.

5 Continue adding markings, and use the tip of the brush to hint at horns, the tail and udders.

6 Dilute the Payne's gray and paint some simple shading on the bottom of the shapes.

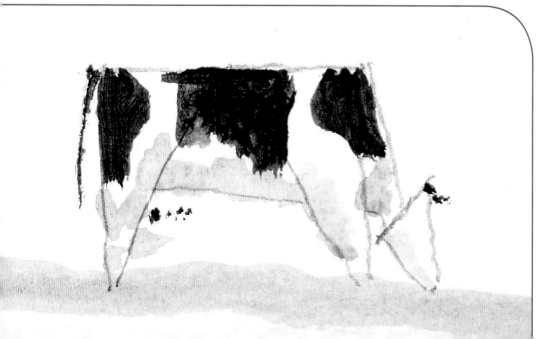

7 Add a little grass in the same way as under the sheep.

Simple boats on the water

Farm animals and figures are fantastic, but they won't be suitable for every painting you make – they'd get a bit damp in an ocean scene, for example!

A boat will make a good focal point for a seascape like this, and they're easier to draw than you might think.

1 Use your HB pencil to draw a simple fish shape, as shown.

2 Draw three lines descending from the fish, then add a wavy line as the water – there, a complete rowing boat!

3 Draw a second in the same way, next to the first.

4 You can make the same basic boat shape into a fishing boat by adding a box on top.

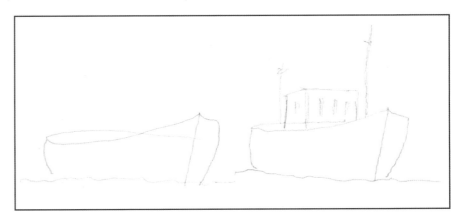

5 A few lines to look like masts and aerials will help make the boat look more convincing.

Boat on the beach

This is a great exercise for teaching control of the round brush, and using the tip in particular. A boat on the beach is a great way to add some strong lines to a coastal scene.

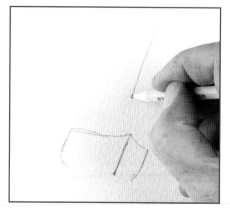

1 Draw a boat using the technique opposite, but place it slightly on its side and add a line at an angle for the mast.

2 Use the size 8 round to paint the right-hand side (the part in the shade) with raw umber.

3 Add water to dilute the mix, and paint in the left-hand side.

4 Paint the mast with Payne's gray, and dilute to paint the inside of the boat.

5 Add a little mud with raw sienna; then use dilute Payne's gray for the shadow beneath. Have the cast shadow extending over to the right-hand side – don't forget the shadow of the mast.

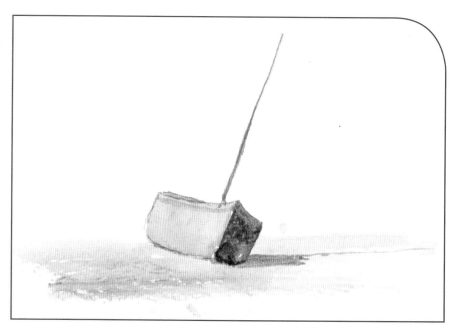

Painting in the watercolour style

Acrylics can be painted using exactly the same methods and style as you would paint a watercolour, with loose, free washes and speedy application for clean, beautifully fresh results.

Acrylics have a number of qualities that make them easier to work with than watercolours: You can put light colours on top of dark once the paint is dry, and the colour you put on the paper is the colour it will stay once dried. They do not dry lighter in tone, as watercolours do.

Whether you have painted with watercolour before or not, you are in for a treat on the following pages, as we explore how to use acrylics with free-flowing washes.

Acrylic techniques: watercolour style

As explained earlier, acrylics can be used to paint on virtually anything. The examples within this book start with a very loose style, as in watercolour, and progress to a more detailed, intricate style once we get to canvas.

For the watercolour-style way of painting on the following pages, we will concentrate on using watercolour paper as our surface. However, note that the techniques you learn here can be used on canvas too, so as you progress through the book and learn about a more detailed, precise way of working, don't feel constrained, but use them in combination.

My intention is not to have you working with just one set of techniques, but to show you some of the versatility of the acrylic medium. I want you to enjoy painting, so that you can use your acrylics exactly as you want to. In this way, I hope you will come to think of these techniques less as watercolour- or oil-style techniques, but simply as painting techniques.

Fresh, clean watercolour-style results are at your fingertips with the instructions and exercises on the following pages – jump in!

Washes and lifting out: clear sky on paper

These techniques can be used to paint a really simple fluffy-clouded sky on paper. It gives a bright and sunny result, and is a perfect way to practise using very wet paint in a watercolour-style 'wash' to cover the surface.

While the paint remains wet, the brush is cleaned and squeezed out, then touched to the surface. The dry bristles will draw up some of the paint, lifting out a space in the paint: perfect for clouds.

1 Wet the surface with plenty of water, then drop in very dilute raw sienna at the bottom using the size 28 flat.

2 Brush the colour back and forth, working the wash upwards into the wet area.

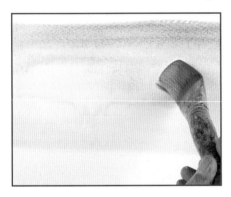

3 Mix cobalt blue with titanium white and, starting from the top, paint downwards in broad horizontal strokes until you reach the raw sienna area.

4 Rinse and squeeze excess water out of your brush and lift out the wet paint to create big fluffy clouds.

5 Use the paint on your brush to very lightly touch the bottoms of the clouds – this will let a little paint bleed back in to create a shadow.

Sunny Coastline

A simple beach scene calls for a clean bright sky. I used broad strokes of raw sienna for the beach, leaving a space for the sea. The water is cobalt blue with a hint of Hooker's green, added using the blade of the brush to apply the paint in broken strokes, leaving some white spaces to suggest waves and highlights. The sand dunes are a mix of Hooker's green and raw sienna, and a mix of alizarin crimson and cobalt blue was used for a few scattered details.

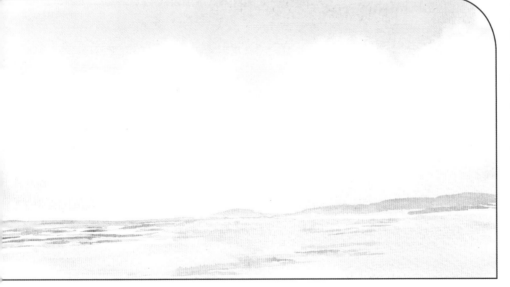

Wet-into-wet: stormy sky on paper

The wet-into-wet technique is simply adding wet paint to washes that have not yet dried. This encourages the colours to float together and blend, giving soft results. The amount of time you leave the wash before adding colour will affect the result – the drier the surface, the less the paints will blend, so this exercise will let you practise adding colours at different times. This stormy sky is approached in much the same way as the clear sky.

1 Give yourself the time to move the paint around. wet the surface with plenty of clean water using the size 28 brush. Using a mix of dilute cobalt blue and titanium white, paint the wet surface.

2 Don't make a flat, dark sky; add some warmth. Add burnt sienna wet-in-wet in a sweeping motion.

3 Add a dilute mix of Payne's gray and cobalt blue wet-in-wet, leaving some of the burnt sienna showing.

4 Rinse your brush and squeeze out excess water. Press the brush onto the surface to draw paint into the bristles and off the surface.

Tip

If the paint dries too much, you can end up with unpleasant 'backruns' or 'cauliflowers' when you add your next colour, so work confidently and swiftly. If it all goes wrong, don't be discouraged; just start again on a fresh piece of paper until you get the knack.

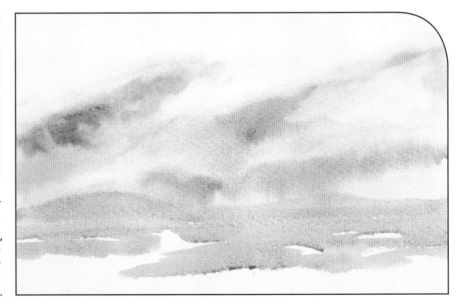

Stormy Moor

Try adding a simple landscape beneath the sky to make a simple finished picture. Here, a few strokes of a dilute moody green mix (Hooker's green and raw umber) sit below the faint silhouettes of mountains on the horizon, painted with watery cobalt blue.

Your first painting

The following pages lead you from the exercises you have already tackled, on towards a full painting project. There's nothing to worry about – the exercises will have prepared you and given you all the skills you need to paint in a watercolour style.

Before we begin, here are a few extra tips and tricks to help you with your painting and drawing.

Testing your mixes

Some papers have a slight tint that can make the paint appear different once applied from how it looks on your palette. To avoid unpleasant surprises, before you apply a new colour or mix to your painting, try it out on the same surface as you are painting on. This will ensure that it will appear the same on your final painting.

You might use a spare piece of the same paper or, as shown here, to the side of your painting. Doing this will make sure that the colour is just right before you apply it to your picture. It also works as a good aid to your memory if you need to make more of a particular mix.

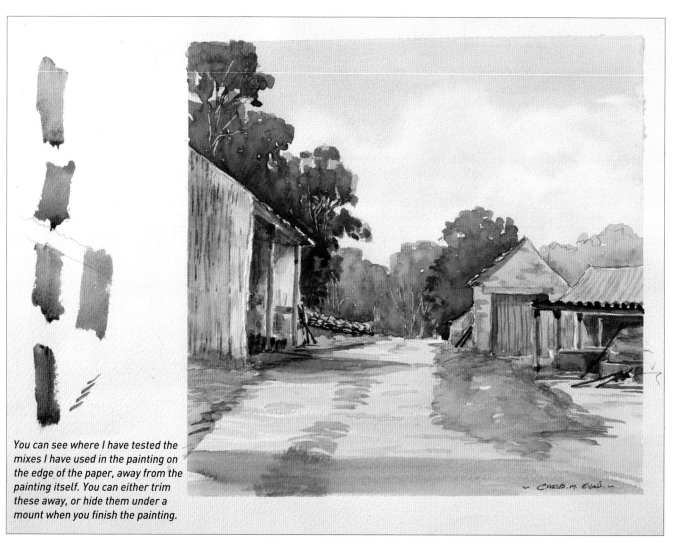

You can see where I have tested the mixes I have used in the painting on the edge of the paper, away from the painting itself. You can either trim these away, or hide them under a mount when you finish the painting.

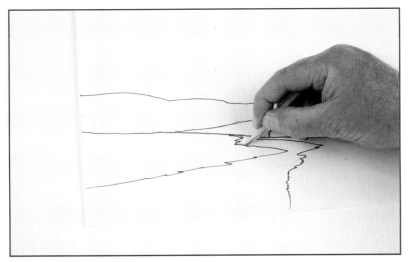

1 Scribble over the back of the outline paper with a soft 2B pencil.

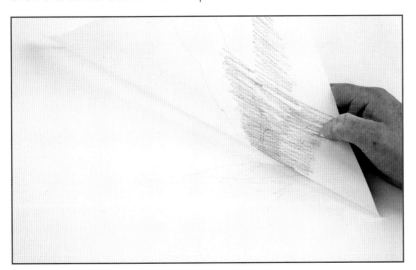

2 Turn the paper over and tape it down over your watercolour paper. Draw over all the lines with a hard pencil.

3 Lift up the outline to reveal the drawing transferred on to the watercolour paper ready for painting. You may need to reinforce some of the lines with a pencil directly on the watercolour paper.

Transferring the outline to paper: tracing the design

The outline drawings for the step-by-step projects in this book are provided; you can transfer the outline to watercolour paper using the technique below.

Other ways of using the outlines

The outlines are intended to be used to help build your confidence if you are starting out. You can also use the outlines to quickly and repeatedly practise the same project without having to draw the outlines each time.
This will allow you to try different painting techniques or approaches to the subject – for example, you might try repainting a project as a night scene, change the season from winter to spring, or add some figures to your work. This will allow you to use the information later in the book to create your own version of the painting demonstrations.

Of course, you don't have to use the supplied outline drawings at all! If you prefer, try drawing the image freehand by copying it from the outline onto your paper. This is a good way to practise your drawing skills.

Sunlit Field

You will need

300gsm (140lb) Not surface watercolour paper; pencil; water pot; masking tape

Colours: titanium white, cobalt blue, Payne's gray, raw sienna, Hooker's green, burnt sienna, raw umber and alizarin crimson

Brushes: size 28 flat, size 18 flat, size 8 round, size 2 round

This relaxing landscape uses the techniques you learned for painting a clear sky with those for painting trees, combining them into a complete landscape painting. Here we will extend those lessons, introduce more detail, and aim to capture the light in the field and in the trees.

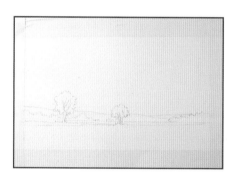

1 Transfer the image to paper, then run masking tape round the image to create a border and secure it to your board.

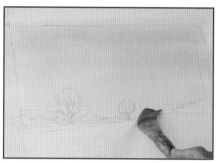

2 Wet the sky area with lots and lots of clean water using the size 28 flat. Mix a little cobalt blue into titanium white, dilute with more clean water, and paint the sky area using this mix in broad horizontal strokes from the top down to the horizon.

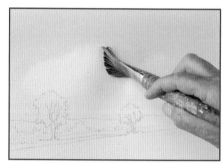

3 Rinse and dry your brush and use it to lift out clouds by pressing the bristles into the wet paper.

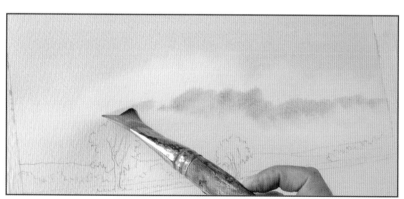

4 Add a little Payne's gray to the sky mix and add the colour to the base of the clouds. While the paint remains wet, use the corner of the brush to encourage the shadow upwards into the clouds a little.

5 Try not to fiddle or adjust the paint too much – you want to get a clean result, so if it looks right – leave it alone!

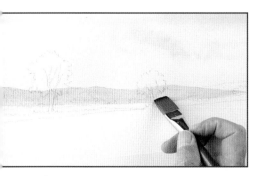

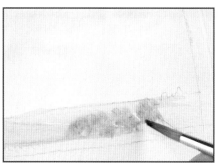

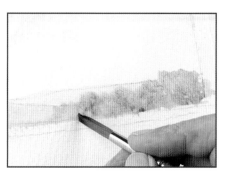

6 Add a tiny touch of alizarin crimson and plenty of water to the shadow mix and use the size 18 brush to paint the distant hills. Again, aim to work quickly and cleanly – don't add unnecessary detail.

7 Change to the size 8 round brush and mix raw sienna with a touch of Hooker's green. Dilute the mix heavily. Use a dabbing motion to paint the distant trees. There is no need to wait for the hills to dry completely – the paint will not 'bleed' far.

8 Add a little dilute cobalt blue to vary and suggest shadows in the distant trees.

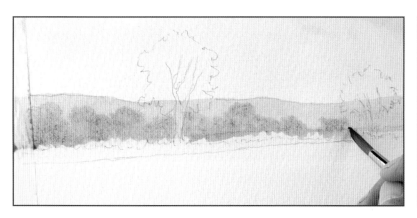

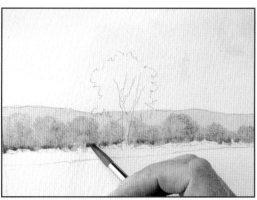

9 Strengthen the green mix by adding more of each paint, then paint the midground foliage in the same way, using slightly larger touches of the brush.

10 Tap in blue shadows with the dilute cobalt blue.

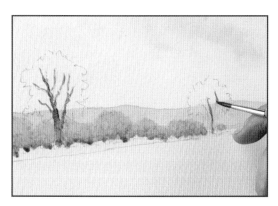

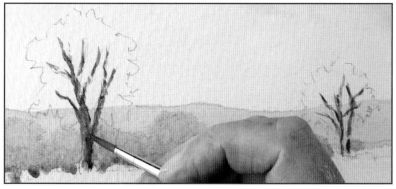

11 Change to the size 2 round and paint in the large tree trunks and main branches using raw umber.

12 Add Payne's gray wet-in-wet as shadow.

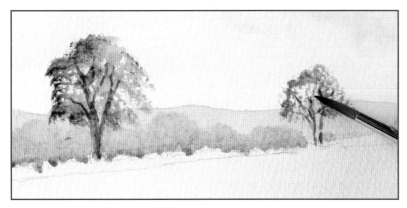

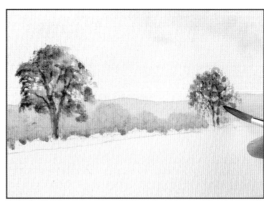

13 Using the size 8 round, apply a mixture of Hooker's green and burnt sienna to the tree foliage. Do not dilute the paint as much as for the sky wash. Dab the bristles side-on on to the surface to create a broken effect. Add a little more water to the mix for the more distant tree.

14 Mix cobalt blue with Payne's gray and use this to dab a few touches of shadow in the foliage to suggest depth and detail.

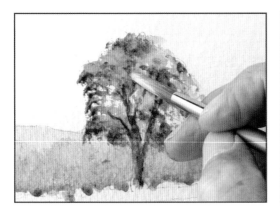

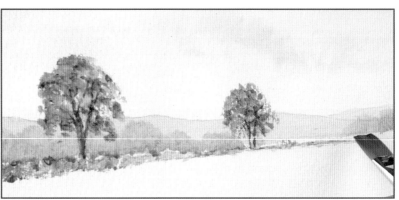

15 You can add some highlights into the foliage with a few light touches of Naples yellow while the paint remains wet.

16 Using raw sienna, add the edge of the field with small brush strokes. Drag the side of the size 18 flat brush upwards slightly on the left, and use the tip of the brush itself for the more distant area.

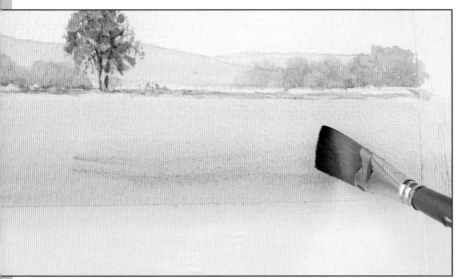

17 The foreground field is treated in much the same way as the sky wash: wet the area with clean water, then add dilute paint wet in wet. The only difference is the mixture – using raw sienna and raw umber to paint it, and adding a tiny touch of burnt sienna in the foreground.

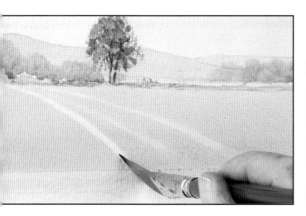

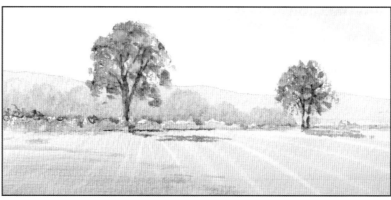

18 Wash the brush and squeeze out excess water. Draw the 'blade' of the brush down the field to lift out narrow highlights. Change the angle of these to suggest distance.

19 Add the shadows cast by the trees using a dilute mix of Payne's gray with alizarin crimson, applying the mix with the corner and blade of the size 18 brush. Finally, dilute the mix further and add some shadow leading in from the left-hand side.

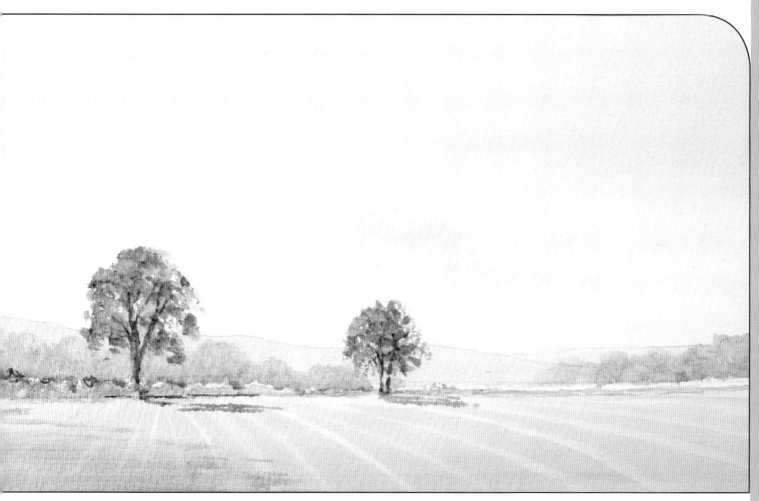

The finished painting.

Beach Walk

Although the sky in this beach scene looks complex, it is painted using the same watercolour-style techniques as the stormy sky on page 41. I have used stronger colours than in the project, and lifted out more shapes.

Outline 2

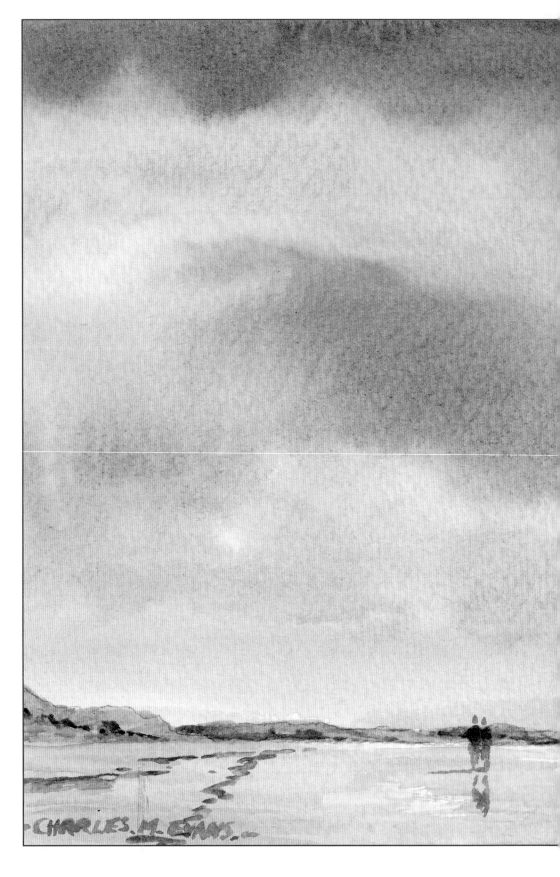

CHARLES. M. EVANS.

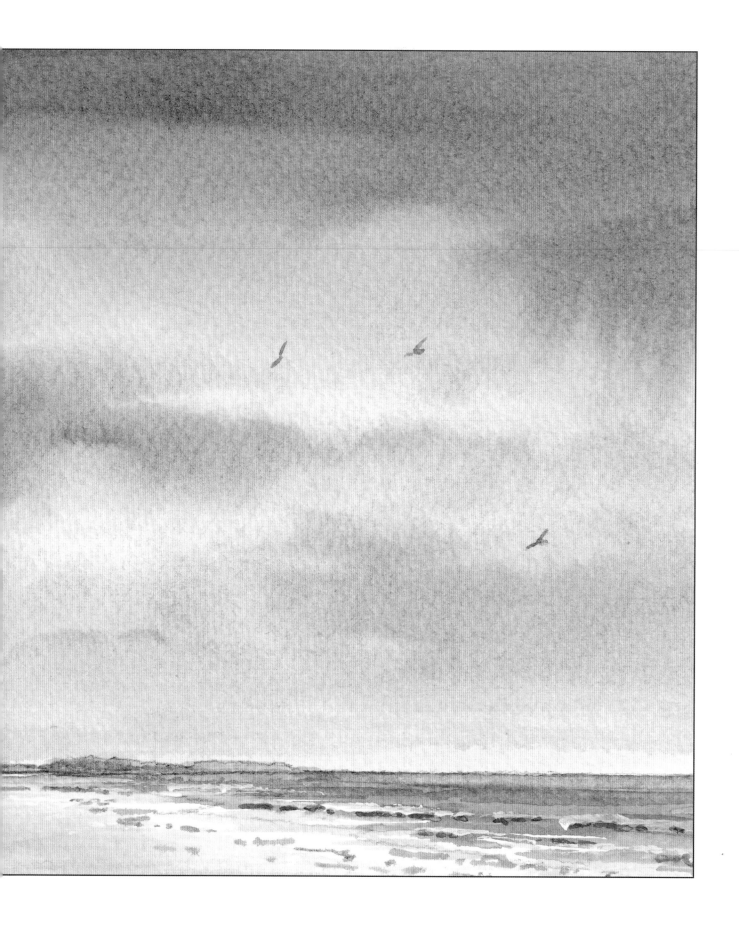

Painting in the oil style

We've tried out using acrylics with watercolour techniques, but this versatile medium has more tricks up its sleeve. As well as watering it down and using it for dilute washes, it can be used almost undiluted, allowing you to build up rich, thick, textural layers of paint, an approach that has much in common with painting using traditional oil colours.

Using acrylics in this way has a number of advantages over traditional oils – there is no unpleasant smell, you don't have to use special thinners (just water), and acrylics dry much faster than oil paints, allowing you to work quickly. Using acrylic paint thickly means that you can paint lighter colours over darker colours, which makes the process of painting relaxing, as you can even correct any little mistakes.

The oil-style techniques here can be used on paper, but since this style of painting allows us to work on canvas, that's what we'll concentrate on here.

Acrylic techniques: oil style

Painting acrylics on canvas is a totally different discipline, but just as easy as on paper, so don't panic. All that you're doing differently is making the paint thick and strong and making sure you don't use too much water in any of the mixes. These mixes need to stay put when you put them on.

When painting in an oil style on canvas with acrylics, I usually put very little water onto my brush or into my mixes, just enough to help them move on the canvas. Everything is good and thick and chunky – much like myself!

At the end of this section, I have included two step-by-step projects. The first, *Farmhouse*, is painted purely in the oil style, so you can practise the lessons in this chapter. The second, *Woodland*, combines both watercolour-style and oil-style techniques, so you can try out acrylics as they are best used: with a combination of techniques.

Don't be afraid of painting on canvas – the results are rewarding and the process is fun.

Impasto and blending: clear sky on canvas

This exercise will teach you how to paint a bright sky with scattered clouds in a smoothly blended style, a little like oil painting.

Acrylics dry much more quickly than oils, and this can be an advantage. The quick drying time means that you can apply clouds on top of the sky with thick paint (this style of painting is called 'impasto') almost immediately. There is no waiting around for layers to dry!

1 Make a mix of cobalt blue and titanium white. Do not add any water; there's no need. Instead, just use a slightly damp brush. Starting from the top and working downwards, apply the paint with broad horizontal strokes across the painting – just like you are decorating the lounge. Overlap the brushstrokes to avoid gaps, and don't stop during the middle of a stroke, or you will end up with visible brushmarks.

2 Reload the brush as you need to, and as you continue working downwards, add more titanium white to the mix. This will result in a sky that smoothly and gradually gets lighter towards the horizon.

3 Wash the brush out thoroughly, then pick up a thick 'clump' of titanium white on your brush. Dab the paint onto the surface to deposit the paint, establishing the basic shapes of the clouds. If the underlying paint is still wet, you'll need to keep the touches light to avoid smearing and mixing them, and keep reloading your brush.

4 Mix alizarin crimson and Payne's gray and add a little of this mix at the base of the clouds. Keep this subtle – don't add too much.

5 Put the brush down and use your fingertips: roll your fingers around the top of the clouds in small loose circles to smooth and spread the paint.

6 Continue working down the clouds with these small circular motions. Clean your fingers every so often to avoid leaving fingerprints and merging the colours too much – you want the areas of paint to remain distinct.

Druridge Bay

This style of sky is ideal for a simple beach scene like this.

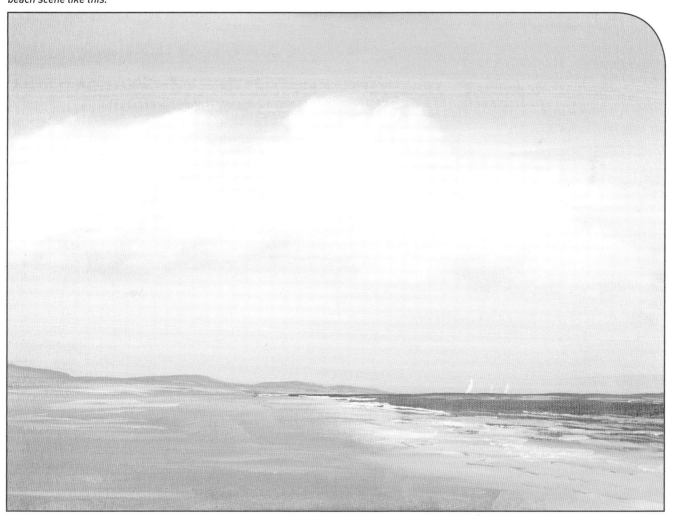

Glazing: stormy sky on canvas

In this exercise, we work more quickly than for the previous clear sky. In addition, we use slightly more diluted paint to create a glaze – a layer of paint thick enough to cover the surface, but thin enough to leave a little of the underpainting colour showing through.

1 Add a tiny touch of Payne's gray to cobalt blue. Apply the mix to the surface using a size 28 flat brush, working from the top down in broad, bold strokes.

2 Add a little bit of burnt sienna to the mix as your progress down the area to the horizon. Once you reach the horizon, wash out your brush.

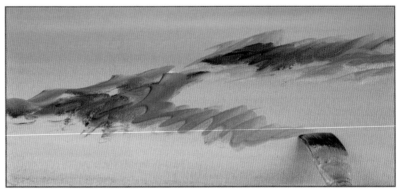

3 Pick up titanium white and begin smoothing it upwards from the horizon, back into the wet sky using the same broad strokes. Work all the way up to the top – this smooths the colours together and brings the whole sky together in harmony.

4 Wash out the brush well and pick up Payne's gray. Apply it to the painting using the tip of the brush in choppy diagonal strokes to suggest brooding dark clouds. You will notice as you work that the brush picks up a little of the still-wet sky – this is not a problem; the colours will blend smoothly.

5 Add raw umber here and there within the clouds to add threatening warmth.

6 Wash the brush out thoroughly and begin to smooth in the paint with your fingertips. Work gently to break up any brushmarks and merge the colours together.

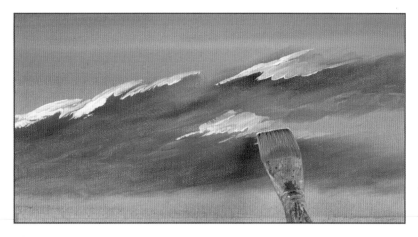

7 Pick up a clump of white on your brush and begin to highlight the tops of the clouds. Instantly, the contrast will make the dark clouds more striking and effective.

8 Very subtly merge the white into the tops of the clouds with your fingertips, but do this sparingly; leave the majority of the cloud dark.

Tip

Step back every so often as you work – don't smooth all the colours together into one muddy mass: leave the basic cloud shapes distinct.

Alnwick Moor

Stormy skies are full of drama. In a picture like this, with a very dark, foreboding sky, using counterbalance in the composition works well. The lightest part of the sky has the darkest part of the land beneath it, and the darkest part of the sky has the lightest area of land beneath it.

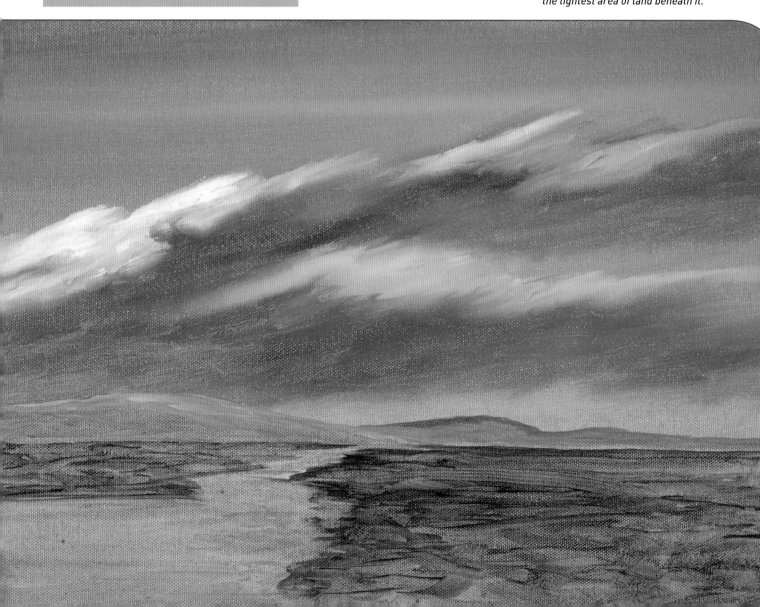

Pre-staining canvas

Pre-staining a canvas helps relieve any nervousness about 'clean white space', by laying in a wash of colour over the whole surface. This is useful because you can leave a little of the undercolour showing through here and there on the finished picture, which avoids leaving just white canvas showing. For example, in a sky wash, have the paint of the sky thinner as you move down the canvas to leave the underpainting showing through, giving a bit of a glow to the sky.

Using a pre-stained canvas also harmonises the painting, because hints of the underlying colour will subtly affect layers on top. So, pick your colour carefully to suit the painting you are going to do.

You can use any colour to add an undercolour to your canvas, but raw sienna is a good warm hue suitable for landscapes.

1 Apply paint straight from the tube to the canvas – a couple of good daubs will do.

2 Use a very wet brush to spread the paint around the canvas. Don't worry about being neat or even; concentrate on getting the entire surface covered.

3 Work the paint right into the surface brushing back and forth repeatedly to make sure it's covered completely. Check to make sure there are no white spots anywhere.

4 Make sure your canvas is completely dry before you work on it. It's a good idea to prepare three or four at a time to make sure you've always got one to hand. You can transfer the pencil to the surface once it's dry.

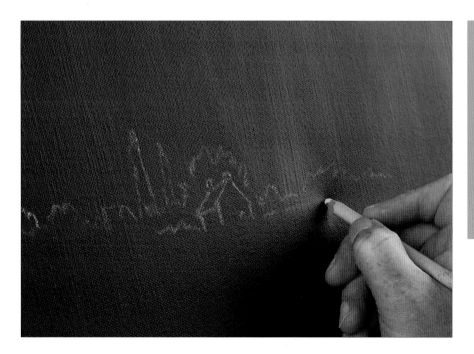

Tip

You are not restricted to light colours for underpaintings. Payne's gray makes a great underpainting for a night-time sky (see St Paul's Cathedral on page 15 for an example of a painting prepared on a Payne's gray underpainting). When transferring the image on to it, you will need to strengthen the lines with a white or other light-coloured watercolour pencil so that your lines are visible.

Transferring the outline to canvas: using tracedown paper

Tracedown paper is like carbon paper, but with graphite (the same mineral used to make pencils). You simply lay the dark side on your canvas, put the outline over the top and then use a pencil or dried-out ballpoint pen to trace over the lines. Avoid putting too much pressure on the tracedown paper, either with your hand or the pencil, as this can scar or dirty your canvas.

It is a good idea to reinforce the outline once it is on the surface, as your brush may wash off some of the pencil when you begin to paint. The image transferred in this way can be erased, as with a normal pencil drawing.

Tip

Tracedown paper can also be used to transfer the outlines to watercolour paper, and you can use tracing paper (see page 43) to transfer outlines to canvas as well as paper – use whichever method you prefer.

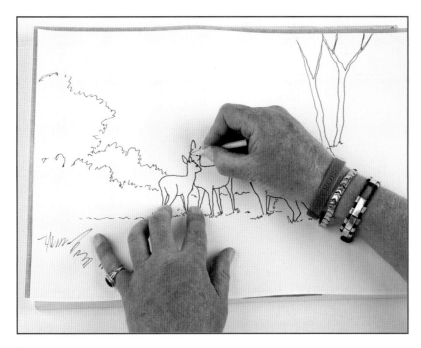

1 Tape your canvas to a painting board, then place tracedown paper on top. Tape your outline on top of this. Go over the lines with a hard pencil.

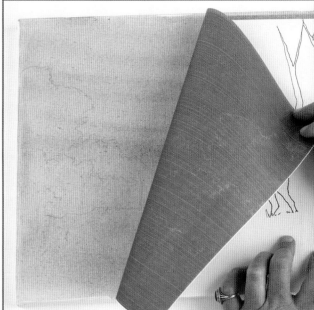

2 Lift the outline and tracedown paper to reveal the drawing transferred on to the surface.

Farmhouse

A winding road leads to a farmhouse set amidst a fairly flat landscape, beneath a big expansive sky. This kind of painting makes the most of the biggest wash brush – and more than that, it showcases the versatility of acrylics in the oil style.

You will need

Primed 100 per cent cotton canvas; pencil; water pot; masking tape

Colours: raw sienna, cobalt blue, titanium white, Payne's gray, burnt sienna, Hooker's green, raw umber, Naples yellow

Brushes: size 28 flat, size 2 round, size 8 round, size 18 flat

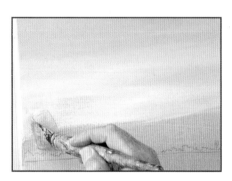

1 Transfer the image to the surface, then pre-stain the painting with very dilute raw sienna and the size 28 flat brush. Allow the underpainting to dry before continuing.

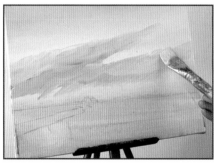

2 Using a light blue mix of cobalt blue and titanium white, begin to paint the sky using the size 28 flat, starting from the top of the canvas.

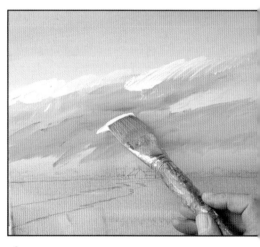

3 Add more white into the mix as you work down the canvas to create a gradient effect.

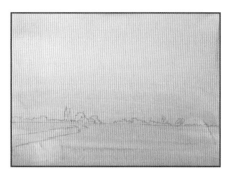

4 As you reach the bottom of the sky, dilute the mix a little. This will let the pencil underdrawing show through. Note that some of the pre-stain will show through too, adding warmth to the sky near the ground.

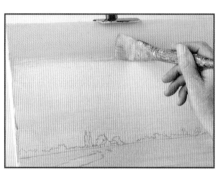

5 Add quite of bit of Payne's gray to the sky mix and shape the darker clouds, bringing them up at a slight diagonal as shown – this adds movement to the sky.

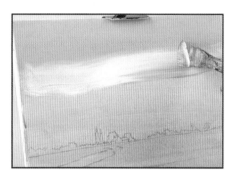

6 Wash the brush out well and pick up a good thick clump of titanium white on the brush. Use this to add the lighter tops to the clouds.

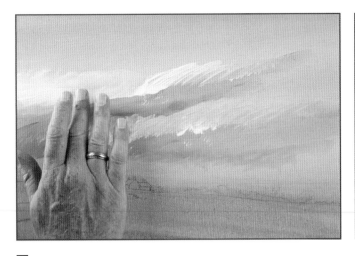

7 Get rid of the brush and use your fingertips to shape the clouds. Use small, circular rubbing motions to blend the different areas of colour together. Clean your fingers every so often to avoid merging all the paint into a solid grey.

8 Continue shaping the clouds with your fingertips. This technique allows you to feel the canvas and gives you great control – so enjoy! Aim to smooth out any brushmarks or fingermarks, while retaining the difference in colour.

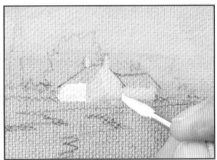

9 Using the size 2 round brush, apply titanium white straight from your palette to the central building on the horizon.

10 Mix a little cobalt blue into the white and paint the side of the building in shadow. White in shadow is not white!

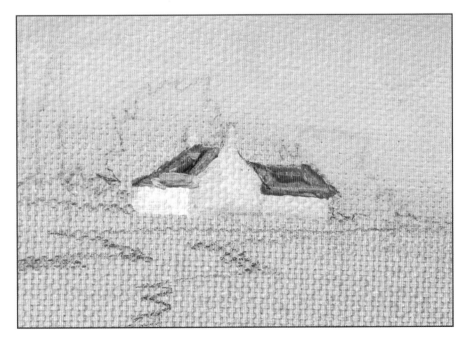

11 This is a distant house, so there's no need to fuss around painting detailed sash windows and net curtains; just add the roof with a little burnt sienna.

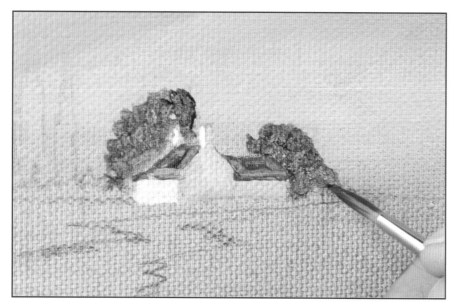

12 For the trees behind the building, use a mix of Hooker's green and burnt sienna. This should be fairly strong, as the trees serve to make the building stand out, and so need to be striking themselves.

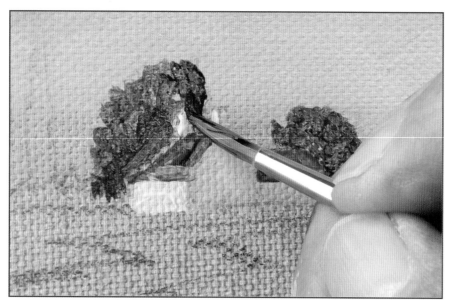

13 Still using the size 2 round brush, add a touch of Payne's gray into the tree where it meets the building. This creates great eye-catching contrast.

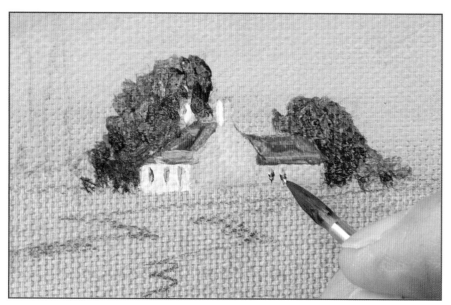

14 Hint at the windows using a touch of the Payne's gray.

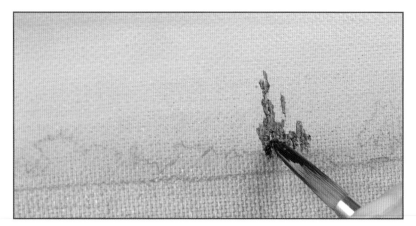 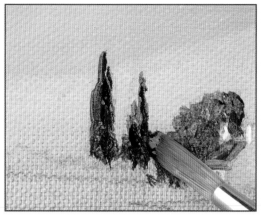

15 Change to the size 8 round and paint the poplars to the right of the row of trees using the tip of the brush and a dark, blue-green mix of Hooker's green, burnt sienna and cobalt blue. These are a simple shape – so keep them simple and don't overcomplicate things.

16 To the right of each of the poplars, use Payne's gray to establish a definite shadow.

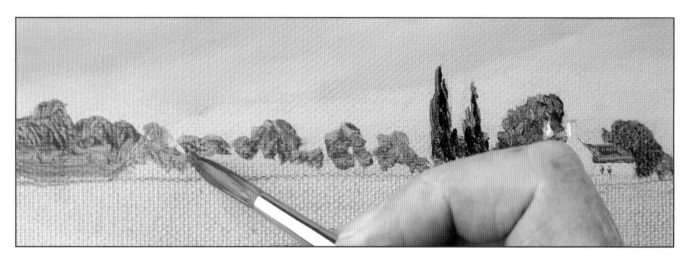

17 It is important to vary the greens when you have lots of trees, to avoid them all blending into an indistinguishable mass. Use raw sienna and Hooker's green as a basic mix to begin painting the distant trees, then add more raw sienna here and there.

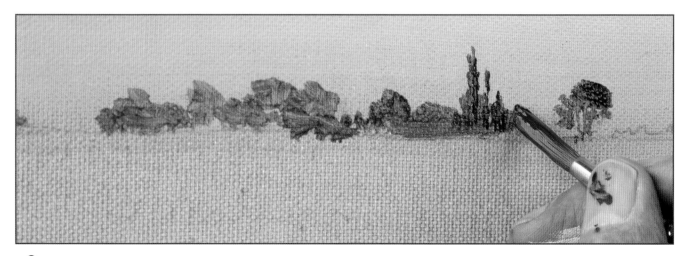

18 Change to a mix of raw umber and Hooker's green as you continue.

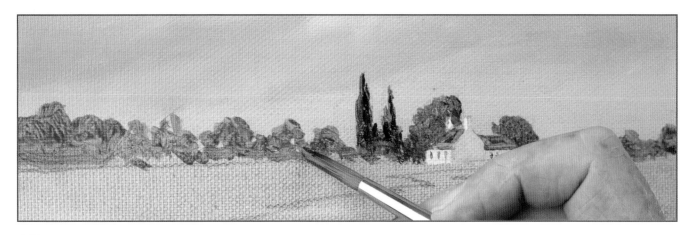

19 A few dabs of pure burnt sienna will enhance the trees by adding some warmth. Add touches here and there in the green area, to pick out and suggest individual trees amongst the mass.

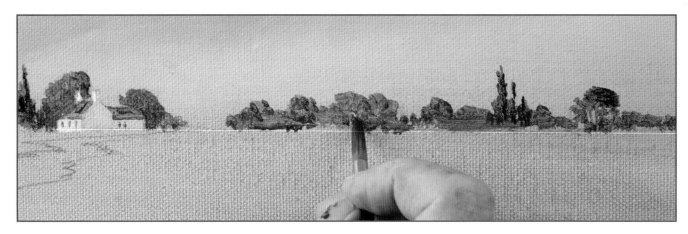

20 Add Payne's gray to the bases of the trees to help anchor them to the ground.

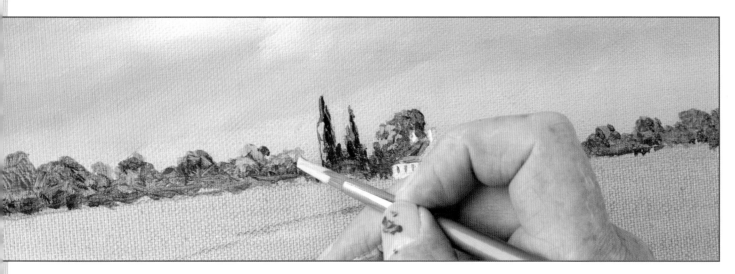

21 Rinse out your brush well, then add some light to the trees using Naples yellow.

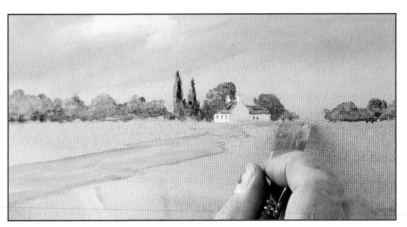

22 If any areas of Payne's gray or Naples yellow stand out too much, use the tip of a clean finger to simply tap the area lightly – this will encourage the paint to blend in.

23 Change to the size 18 flat. Mix raw umber with titanium white. Using the blade of the brush, fill in the path with this warm grey mix to establish a base colour.

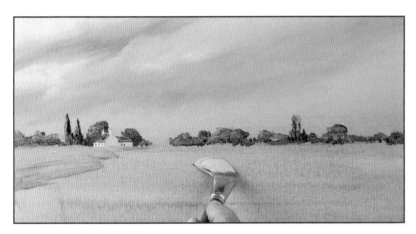

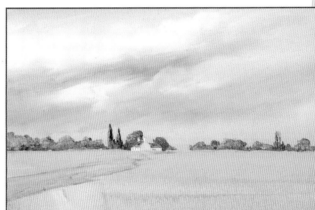

24 To paint the midground area of the field, paint the area with horizontal strokes of Naples yellow. Keep reloading your brush to keep the Naples yellow strong.

25 Work down from the horizon until roughly one-third of the field is covered.

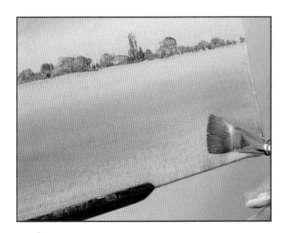

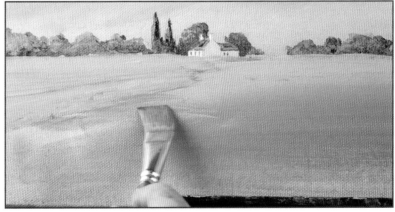

26 Add Hooker's green to Naples yellow and paint the remaining two-thirds. Use the whole of the brush as shown, letting it fan out.

27 As the brush runs out of paint, blend the colour back up into the wet Naples yellow area. This ensures you don't end up with a hard artificial-looking line.

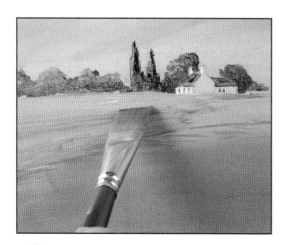

28 Use the blade of the size 18 flat brush to add a few details of the green mix here and there.

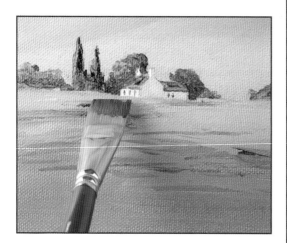

29 Do the same with a little burnt sienna to refine the field and finish the painting.

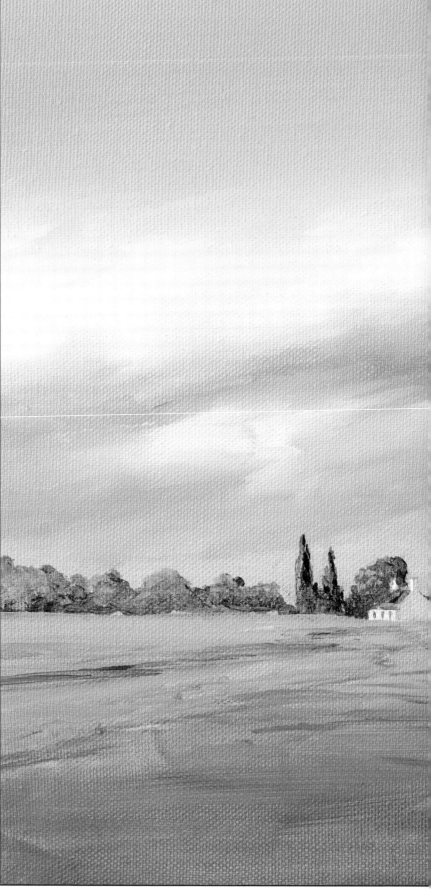

The finished painting.

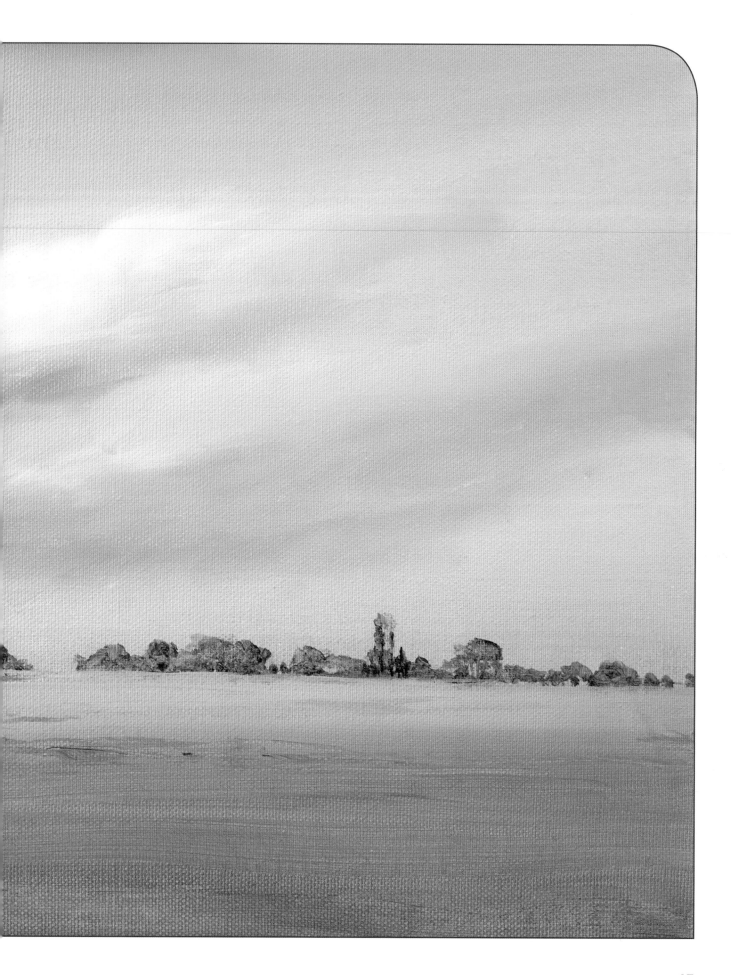

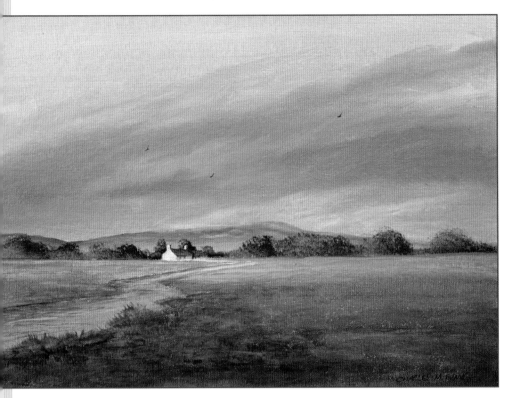

Outline 3

Path across the Moors

The kind of sky I love, fairly powerful without being too daunting and making the most of the light captured below it.

Once you have completed the project, why not try pushing yourself a little further? The painting above is a more developed version of the project painting. Compare the painting above with the finished project painting on the previous page – you will see that the atmosphere of each is different: this one is more moody and dramatic. This was achieved simply by spending a little more time building up the texture in the foreground, and using darker tones in the sky to add contrast. Have a go at your own variation – try altering the colours you use, or aim to create a different mood.

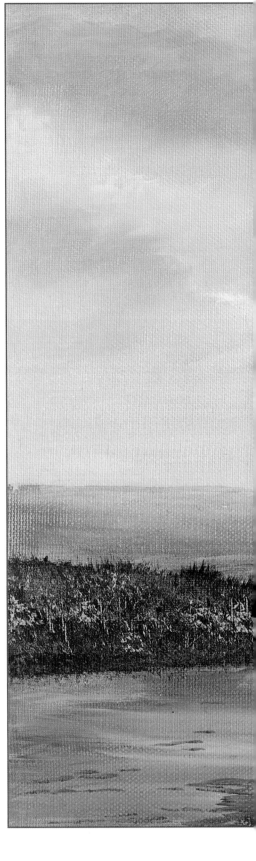

Outline 4

Cresswell

My area of Northumberland: big open beaches, huge expansive sky.

This painting was produced using similar colours to those described in the project. Don't be frightened by the different composition – transfer outline 4 to your canvas and paint the sky exactly as described on pages 58–59, then just carry on with the landscape, adapting the lessons learned to the new image. The only parts that might appear tricky are the foreground grasses, but if you follow the instructions (steps 11 and 28) in the Woodland project on the following pages, you'll find this easy.

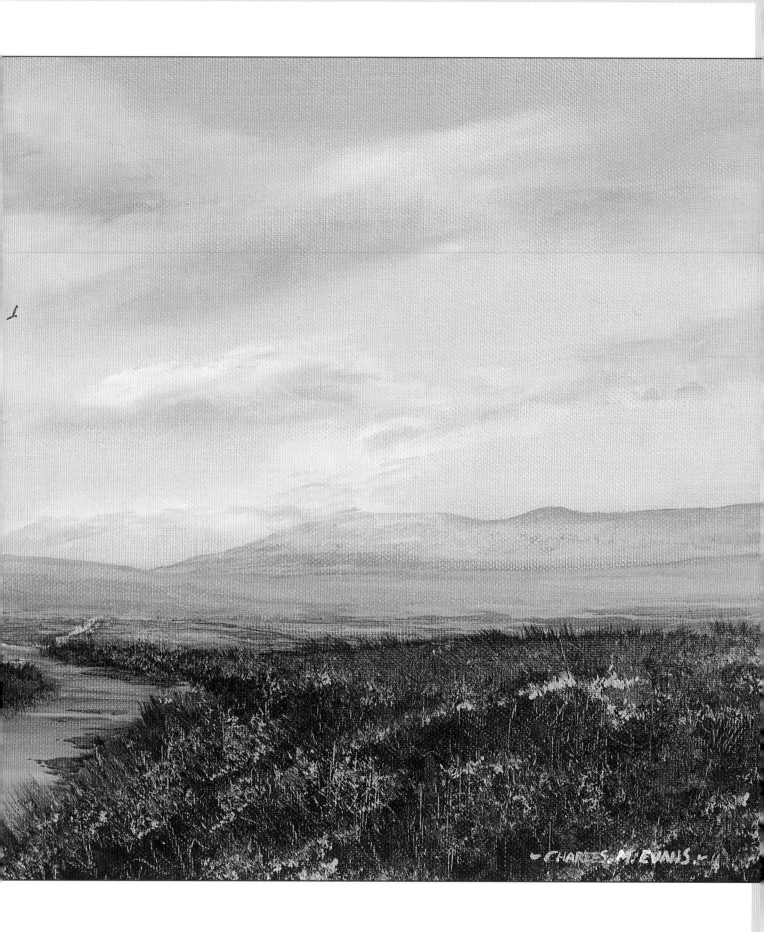

Woodland

This woodland is Acklington Park Woods, very close to my house in Northumberland. The scene includes figures, to create a focal point and give a sense of scale, but the main thing we're trying to create here is the sense of distance, which we achieve by altering the way we paint the trees in the painting – softer in the distance, and clearer close-to.

Painting the mix of sky, foliage and path makes this project a perfect opportunity to combine the watercolour and oil techniques we've learned, to really showcase what acrylics can do.

You will need

300gsm (140lb) Not surface watercolour paper; pencil; water pot; masking tape

Colours: cobalt blue, titanium white, raw sienna, Hooker's green, alizarin crimson, Naples yellow, Payne's gray, raw umber, burnt sienna

Brushes: size 28 flat, size 18 flat, size 8 round, size 2 round

1 Transfer the image to paper, then run masking tape round the image to create a border and secure it to your board.

2 Wet the sky area with plenty of clean water using the size 28 flat brush. Work right over all of the trees and foliage, painting the whole area with cobalt blue and titanium white.

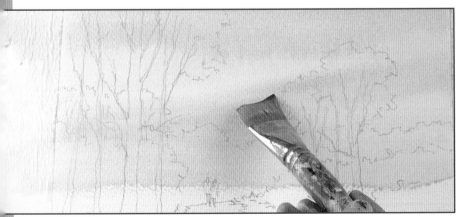

3 Starting roughly two-thirds of the way down and finishing on the horizon, drop a little dilute raw sienna into the base of the sky.

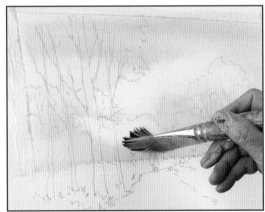

4 Rinse the brush, squeeze out the excess paint; and use the bristles to lift out the paint to suggest clouds.

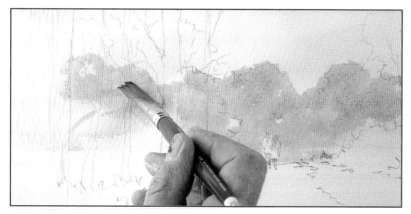

5 Into the distance, add a very weak raw sienna and Hooker's green mix with the size 18 flat brush. Lay the flat of the brush on lightly and repeatedly with dabbing touches. Work right across the pencil lines – don't try to paint within them at this stage.

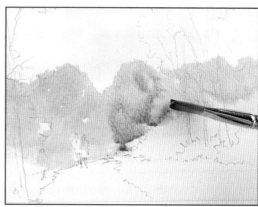

6 Add a touch of alizarin crimson to cobalt blue and dilute heavily. Tap the paint on with the side of the flat brush, concentrating near the bottom of the green areas.

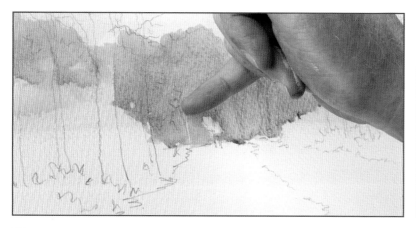

7 Add hints of dilute Naples yellow here and there, allowing the colours to flow and merge together. While the paint remains wet, draw the back of your fingernail upwards into the paint with quick motions to scrape out the trunks of trees.

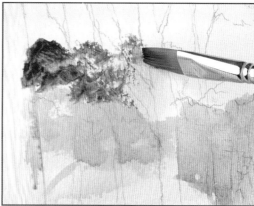

8 Mix Hooker's green with burnt sienna and dilute. Use the size 18 flat to begin to build up the midground foliage with the same dabbing motions as in step 5 – simply work more boldly so that the marks are slightly larger and gaps appear between them.

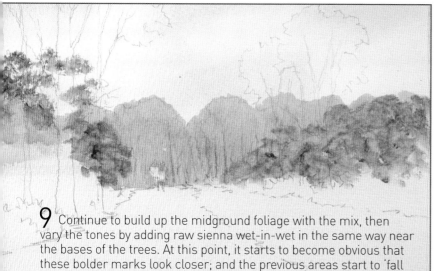

9 Continue to build up the midground foliage with the mix, then vary the tones by adding raw sienna wet-in-wet in the same way near the bases of the trees. At this point, it starts to become obvious that these bolder marks look closer; and the previous areas start to 'fall back' visually.

10 Still using the size 18 flat brush, continue to dab on the midground foliage with a mix of Hooker's green and raw umber.

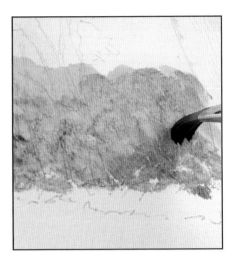

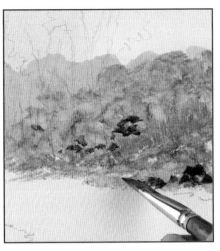

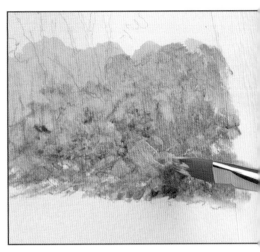

11 Add grasses with quick flicks of the blade of the size 18 flat brush – press it on the surface so the bristles bend, then allow it to flick upwards.

12 Add darks with a dilute mix of Payne's gray and alizarin crimson. Dab this on, adding it mainly between sections. Soften the colour in with a little water for variety.

13 Repeat the process with Naples yellow to add brighter highlights and suggest areas in direct sunlight.

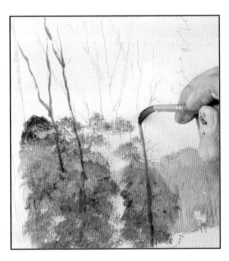

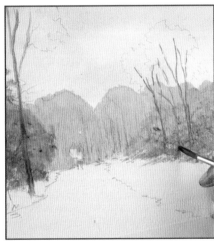

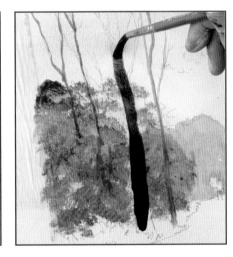

14 Change to the size 8 round brush and use dilute raw umber to paint in the trunks and main branches of the trees on the left-hand side, dragging the brush upwards from the roots to the tips of the branches, and using slightly broken lines.

15 Dilute the raw umber further and add some more trees on the left-hand side. The lighter tone of the diluted paint makes them look more distant.

16 The large trunk of the tree in the foreground is painted using strong Payne's gray and the size 8 round brush. Even though we are using watercolour techniques, acrylic allows you to work light over dark.

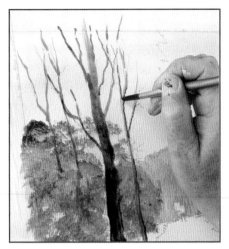

17 Start to add branches with the same mix and brush. Because the tone here is very strong, it pushes the midground trees backwards.

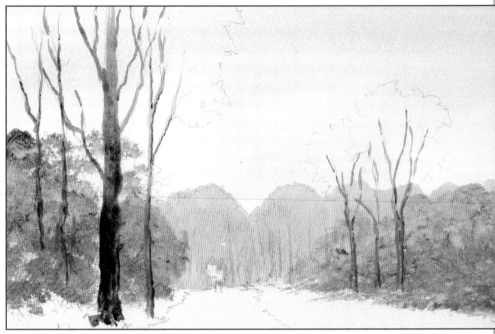

18 Dilute the mix and use it to add some shadows on the branches of the midground and distant trees. At this point, you can see how the painting leads the eye into the distance. A common beginner's error is to make the first marks too dark – and because the distance is the first thing you paint, you are left with no way to darken the foreground effectively.

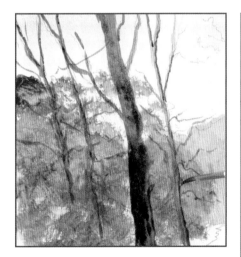

19 Mix raw sienna with Payne's gray and use the size 2 round brush to add some smaller twigs and branches. There is no need to be too precise – they don't even need to all be attached to the trunks as the area will be covered with foliage later.

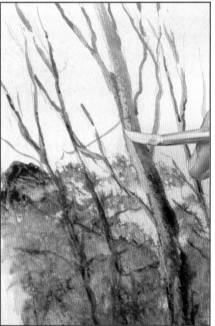

20 Add some life to the trunk of the foreground by tapping on fairly strong Naples yellow using the side of the brush. Keep reloading your brush to keep the colour bright and strong.

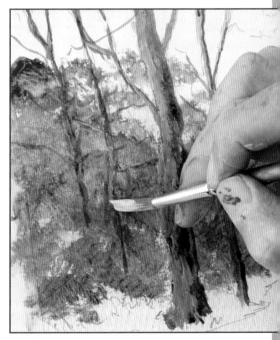

21 Still using the size 2 round brush, use the tip to add similar highlights to the midground trees, working slightly more subtly.

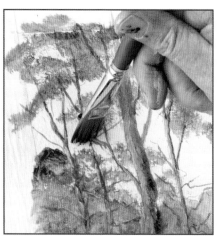

22 Change back to the size 18 brush and split the brush by pressing it firmly into a mix of Hooker's green and burnt sienna on your palette. These brushes are very resilient, so don't worry about damaging them.

23 Use a stippling motion to paint the foliage on the foreground and midground trees on the left-hand side. Twist the brush as you work, to avoid creating a repeating pattern.

24 Dilute the mix a little and repeat on the trees on the right-hand side with slightly smaller marks.

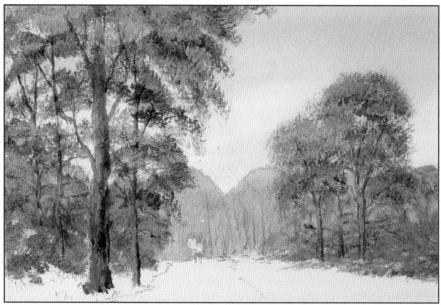

25 Continue building up the area, adding shadow with the same brush and technique by using a mix of Hooker's green, burnt sienna and Payne's gray.

26 Add highlights using Naples yellow In the same way, concentrating these marks near the tops of the trees. Make sure that you don't soften these marks in with your fingertips – you want them to remain hard-lined as this is what creates the impression of hundred of individual leaves.

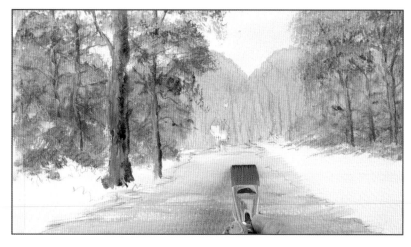

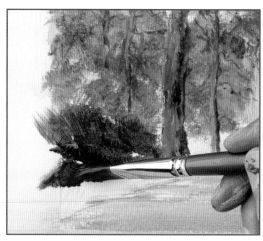

27 Still using the size 18 flat brush, mix raw umber with raw sienna and plenty of water. Quickly brush in the path using light horizontal strokes. Work from the bottom of the painting towards the distance. As the paint on your brush runs out, you will end up with a natural gradient.

28 With a strong green mix of Hooker's green, burnt sienna and cobalt blue, build up the undergrowth with small upwards flicking motions of the blade of the brush to add the impression of grasses.

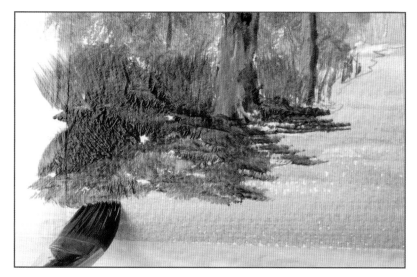

29 Break up the edge of the path, and allow some white paper to remain showing through to create additional light.

30 Starting on the horizon, use the corner of the brush to add a broken central line on the path with the same green mix. As you work forward, make the marks a little broader.

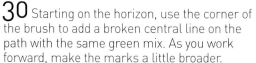

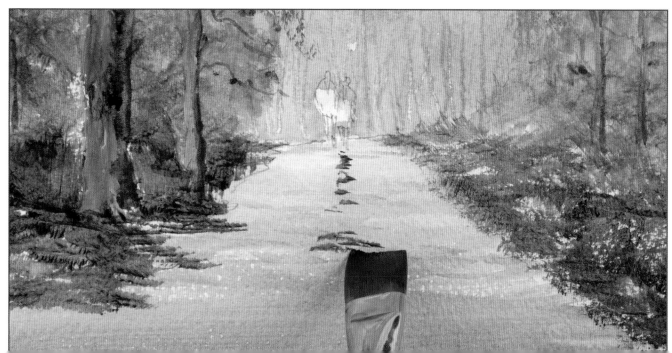

31 Mix Naples yellow with a touch of titanium white and a touch of alizarin crimson. Use the size 2 round brush to paint the skin on the distant figures.

32 Paint the clothing with the same brush. The clothes can be any colour you like – I have used alizarin crimson and cobalt blue for the tops, and a Payne's gray for the legs.

33 Add a tiny highlight to the left-hand sides using titanium white.

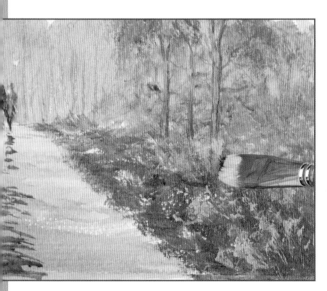

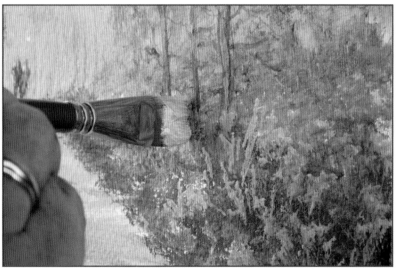

34 Using the split-brush technique (see step 22) with the size 18 flat brush, stipple on Naples yellow into the undergrowth. Remember to twist the brush to avoid regular, even lines – this area should look natural.

35 Add titanium white to the Naples yellow and repeat the process to further develop the highlights.

36 Allow the painting to dry slightly. Prepare a dilute shadow mix of Payne's gray and alizarin crimson. Use the blade of the size 18 flat brush to add the shadows cast by the larger trees. It is important that the shadow follows the shape of the ground – note how the shadows dip into each side of the path and rises slightly in the middle and the edges.

Tip

When adding the shadow cast by an object, always touch the colour onto the base of the object first, before drawing it away. This helps to ensure the shadow 'reads' as being natural.

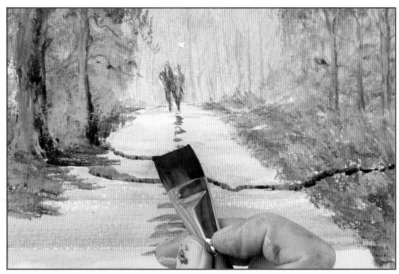

37 Add a shadow that runs right the way across the bottom of the painting, cast by a tree just out of shot – this helps to frame the image.

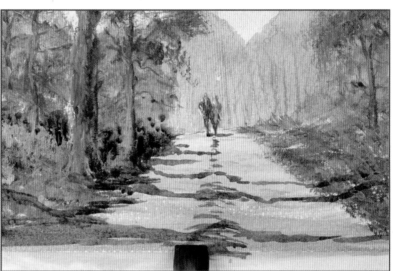

38 Allow to dry, then carefully remove the masking tape to finish.

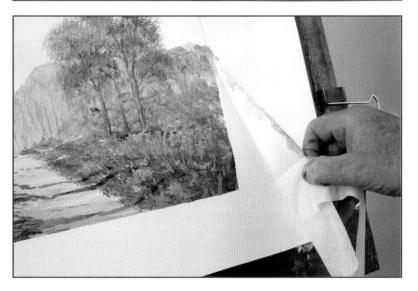

The finished painting.

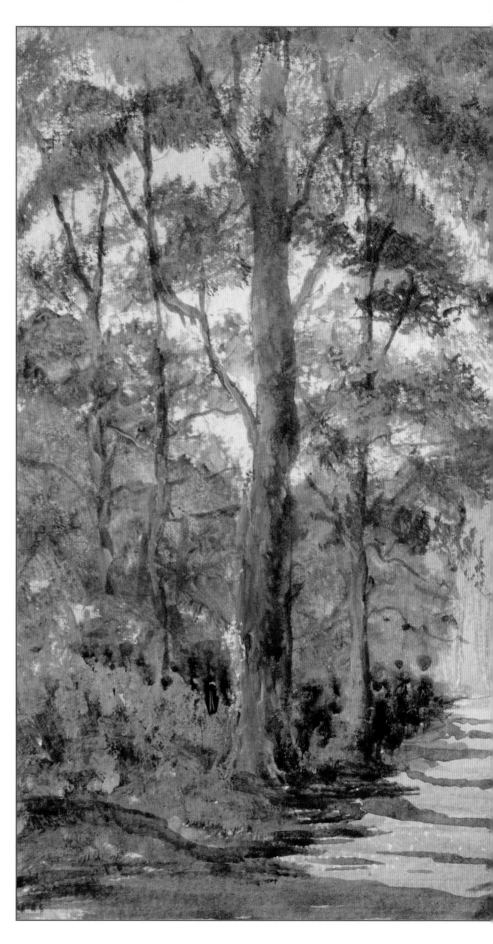

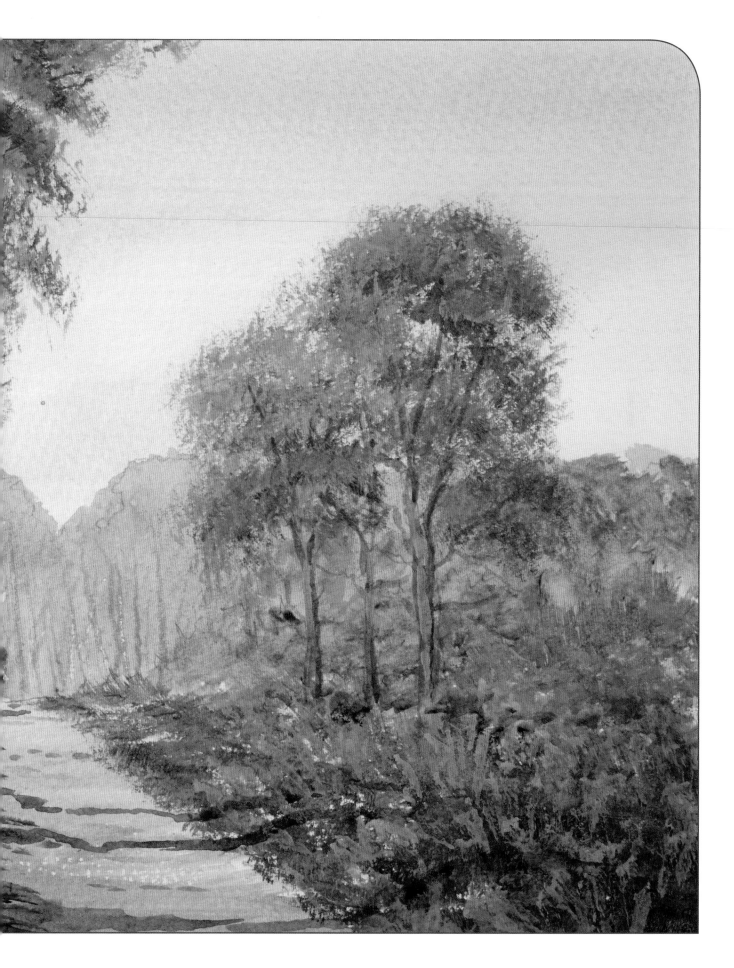

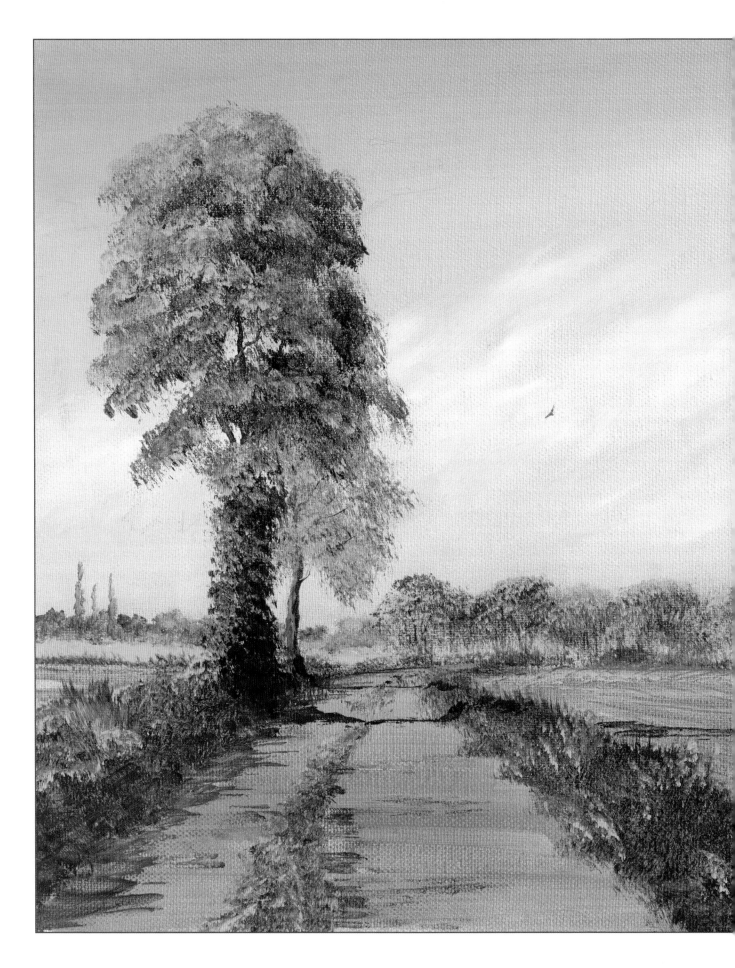

Stubble Time

Using the same techniques as in the woodland project, you can paint this more open composition on watercolour paper or, as here, you can try it out on canvas. The techniques are much the same, but you might like to try using slightly drier, thicker mixes of paint to take advantage of the canvas surface.

Note how the texture of the surface helps to create a sense of softness in the background trees, similar to that produced with watery paint in the project.

Outline 6

Painting buildings and rocks

There are many ways of painting stones, stonework and buildings in your paintings, which can add interest through contrast. The most important lesson of this part of the book is that you don't need to paint everything in detail; suggesting these interesting textures and shapes is often more effective.

Hopefully, the following will give you the building blocks to build your buildings!

Including buildings in your paintings

Buildings add interest to a painting. They will also give a landscape scale and perspective. Try not to be too precise; a little irregularity adds interest.

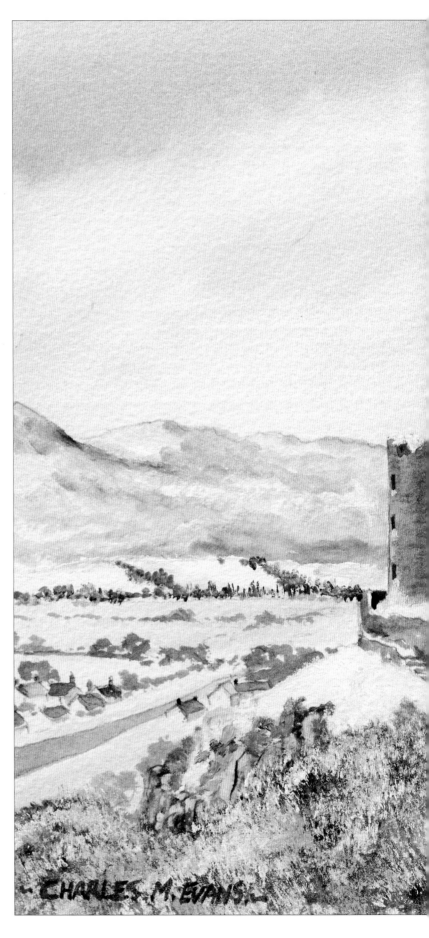

Hard Winter's Day

I particularly liked the composition of this painting: the subtle colours in the distance make the stronger castle stand out well.

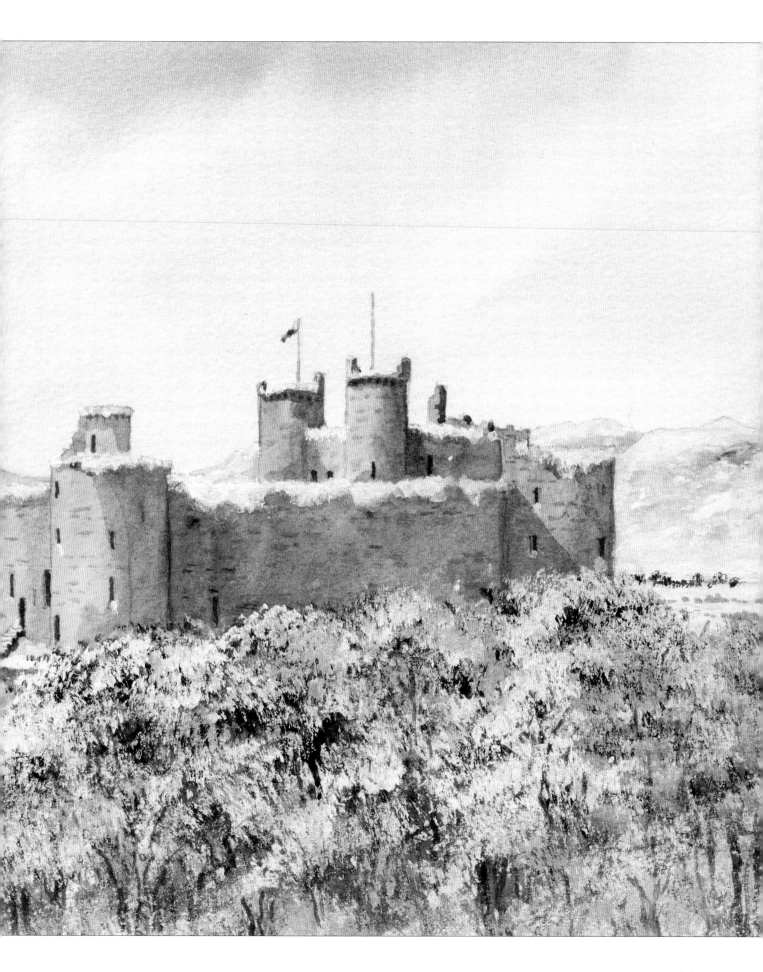

Buildings, perspective and leading the eye

Buildings are great at drawing the eye to a painting. They are often different in colour from the surroundings, and provide straight lines that stand out against softer, naturalistic shapes.

These qualities also make buildings very useful for create a sensing of distance in your paintings: you can use buildings as focal points to lead the viewer's eye into and around your work – just look at the painting opposite for an example.

Opposite
Woodland Cottage

As in the woodland project on pages 68–79, the path helps to suggest distance in this painting – leading into the scene. It is wide in the foreground, and narrows as it progresses. The trees in the foreground and background are also treated differently, to help create recession.

However, it is the light-toned buildings that catch the eye, and this means they immediately create a sense of distance. The shapes and sizes of the buildings – with the roofline dipping downwards slightly, and the more distant building being smaller – really hammer the impression home.

Buildings and detail

The same basic shape can be used in different ways – it is the details that will give the shape an identity as a small cottage or a terrace of buildings. In the examples below, I have used exactly the same basic outline (see right) to create both a lone country cottage (below left), and an entire terraced street scene (below right). In both the top roofline is going downwards slightly, with chimneys getting smaller as they get further away.

It is the details that change the abstract shape into an identifiable building. The cottage has two chimneys, a single door and two large windows that take up most of the space in the wall. Compare this with the terrace, which has more chimneys and many smaller windows and doors.

It is not just the details of the buildings themselves that identify them, either: with a tree you can introduce the countryside; with telegraph poles and a pavement, you can introduce the town.

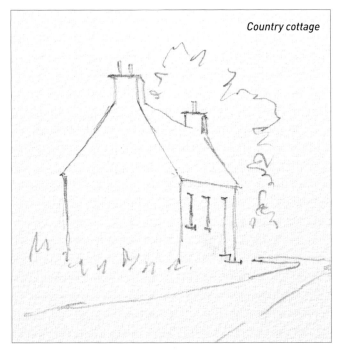

Country cottage

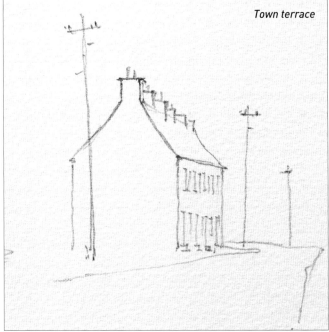

Town terrace

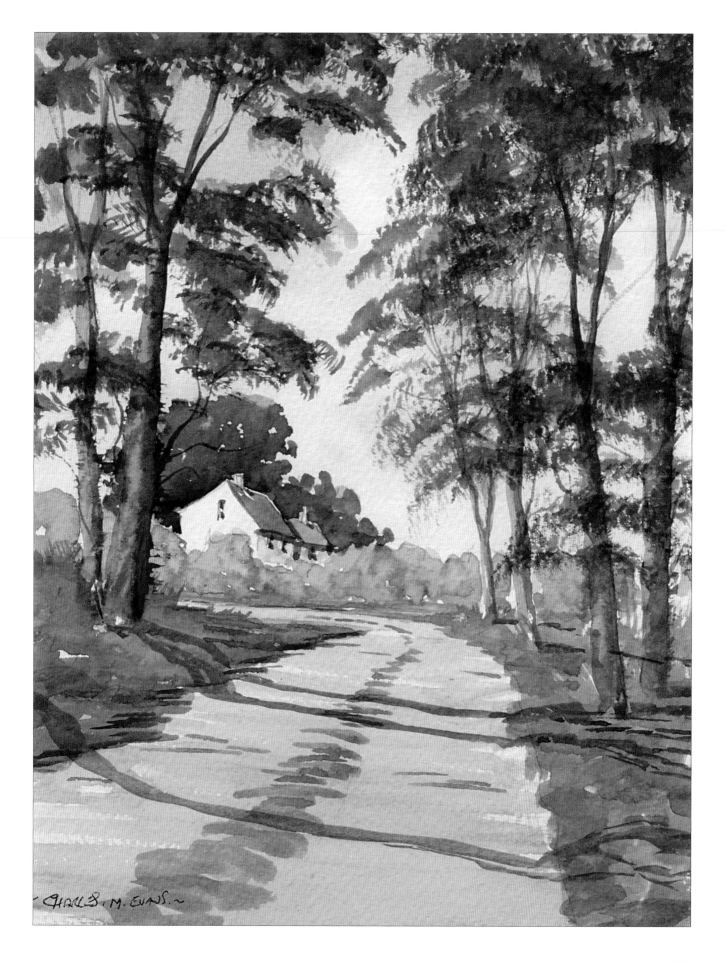

Charles. M. Evans.

Rocky textures

When painting clumps of rocks, don't fiddle about with painting each individual rock. Using a plastic card to scrape the wet surface will lift away a little of the colour and move it, leaving a light area with dark surroundings. This is great for stony textures.

The following techniques depend on the surface on which you are painting. If you are using watercolour paper, Rough or Not surface (short for not hot-pressed) papers are more effective than smooth, hot-pressed paper. The technique will work if you are using canvas, but you may need to take into account the springiness of the canvas.

Drystone wall

The technique is used here to create the impression of a drystone wall. The combination of horizontal strokes with diagonal strokes at the top of the painted area gives quick results.

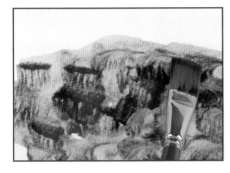

1 Use a size 18 flat to apply some dark, midtone and light colours (raw sienna, raw umber and Payne's gray) in the rough shape of the wall. Work quickly, as the paint needs to be wet for the technique to work.

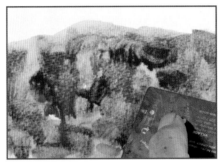

2 Press the corner of the card down so that it flattens and spreads slightly, then drag it a short distance to scrape away the colour in horizontal strokes.

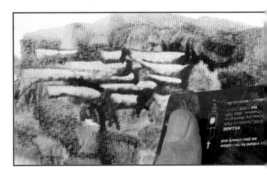

3 Lift the card away, then repeat. Build up horizontal rows of uneven length strokes – this will look more convincing than perfectly even rows.

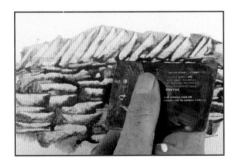

4 Change the angle at which you hold the card for different effects. For the coping stones on top in this example, work diagonally.

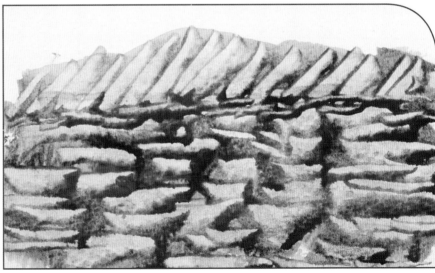

The finished wall.

Farmhouse near Wooler

I loved the autumnal feel here, which prompted me to try to capture the tones and soften the overall theme. The rocky walls are a subtle but important part of this scene.

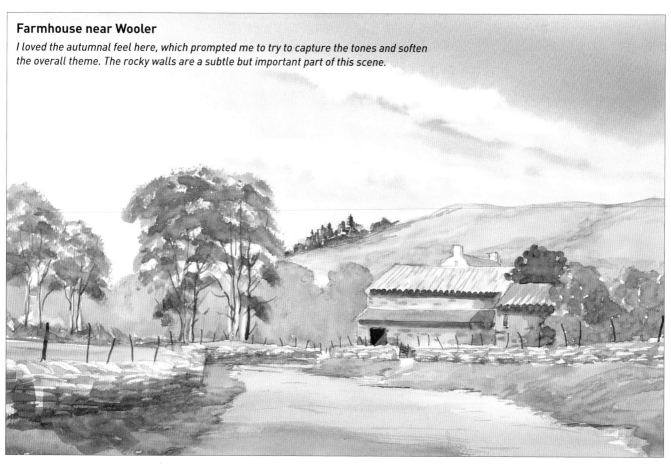

Walkers on Alnwick Moor

A good, strong foreground with a weak background will always gives a painting a dramatic effect, as shown here. Notice how the wall takes us into the distance.

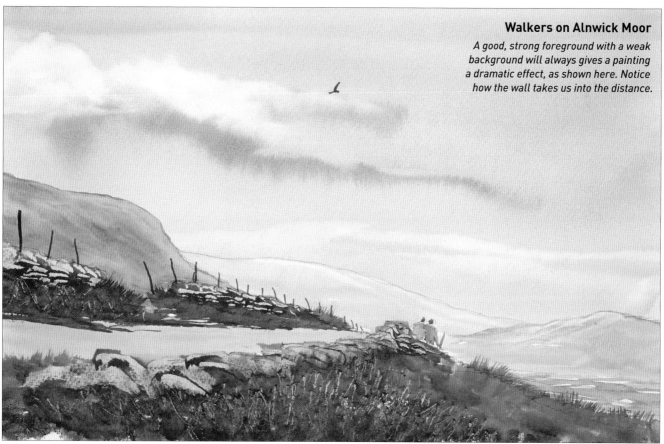

85

Natural rocks

The technique also works for more natural shapes, like this rock formation.

1 As before, apply your darks, midtones and lights very roughly using a size 18 flat. Here I've layered Naples yellow on Payne's gray, itself on raw umber.

2 Use the edge of the card, rather than the corner, to create larger rocks. To avoid an unnatural straight edge, drag the card in curved arcs.

The finished rocks

The effect on watercolour paper is very striking. Note how some of the paint remains behind in the recesses of the paper.

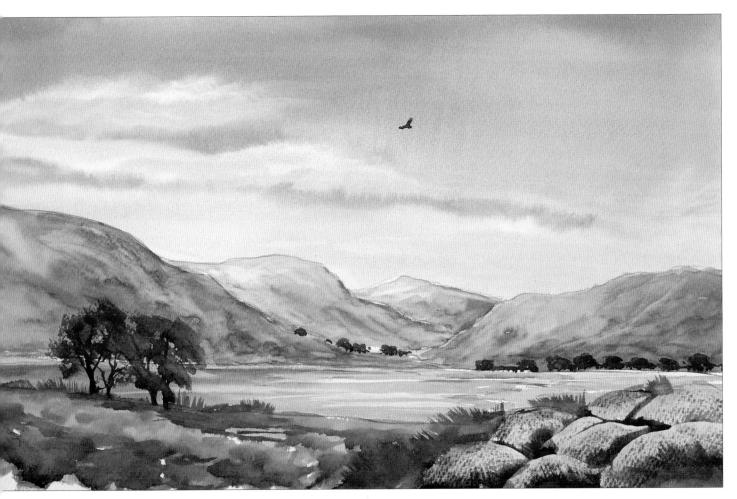

Highland Scene

Recession is built up in the hills by weakening the colours as the mountains get further away. The detail and strong contrast in tones on the foreground rocks acts as an anchor that stops the eye wandering out of the painting.

Mountains

Rocks are fundamentally similar at whatever size, so as long as the area you paint is the right shape, and you scrape in the right direction, this technique makes mountains easy

1 Build up rough diagonal shapes with a variety of tones (I used cobalt blue, Payne's gray and a little alizarin crimson here), then start scraping.

2 Work following the lines of the initial shapes only roughly.

The finished mountains
A few small trees will help to establish the scale.

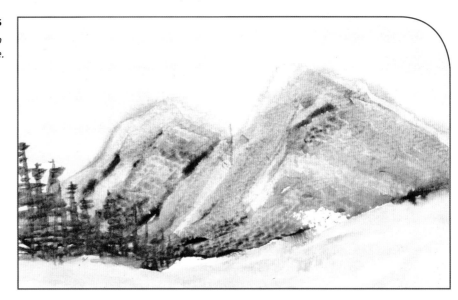

Dunstanburgh Castle
The rocks in this painting, being good and strong, serve to lead the eye into the image and contrast with the fresh, clean sky.

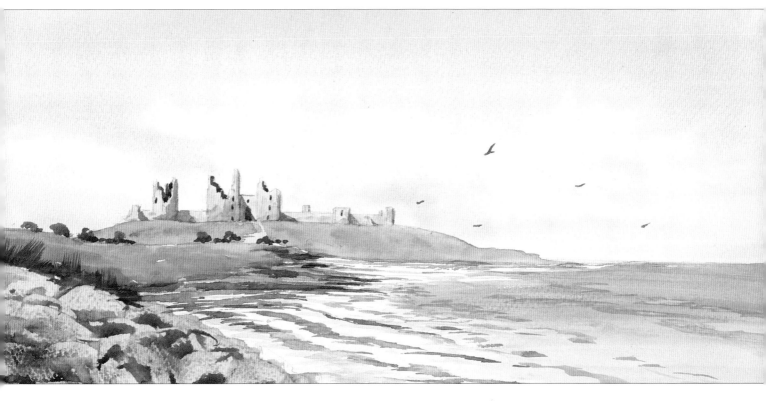

Village Street

Don't obsess about creating perfectly straight lines – this is an old village, and making it sharp and clean will strip out all of the character. You are aiming to create the effect of stonework – don't try to build it stone by stone. This picture is relatively complex, but you can hop from area to area while parts dry. This enables you to keep working while avoiding smudging detail. Using different colours to differentiate the buildings creates interesting contrasts between them and suggests complexity.

You will need

Primed 100 per cent cotton canvas; pencil; water pot; masking tape

Colours: raw sienna, titanium white, cobalt blue, Payne's gray, alizarin crimson, Hooker's green, Naples yellow, raw umber, burnt sienna

Brushes: size 28 flat, size 18 flat, size 8 round

1 Transfer the image to the surface, then pre-stain the painting with dilute raw sienna and the size 28 flat brush. Allow this to dry before continuing.

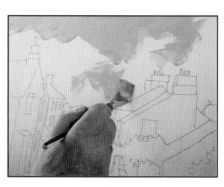

2 This painting uses a different approach to the sky – one that gives a similar effect to a traditional oil technique called 'scumbling'. Use the size 18 flat brush to paint the sky with stabbing motions and a fairly stiff mix of titanium white and cobalt blue, leaving some areas clean.

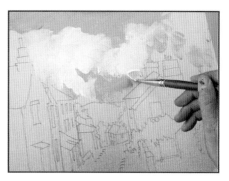

3 Repeat the process with titanium white – there's no need to rinse your brush in between using these colours, as they'll get mixed and blended together anyway.

4 Once the sky area is covered, rinse out the brush well, then squeeze out excess moisture. Repeat the stabbing motion over the sky to soften hard edges and blend the areas together.

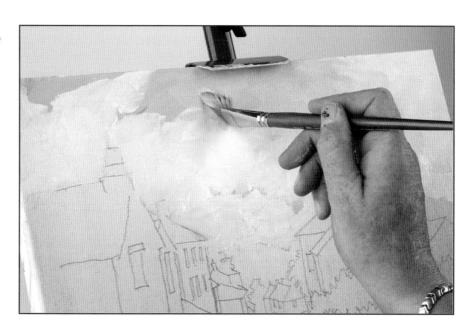

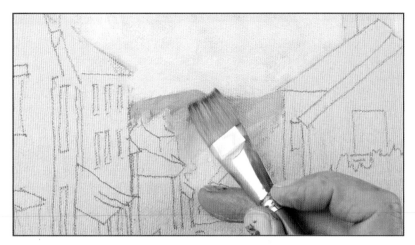
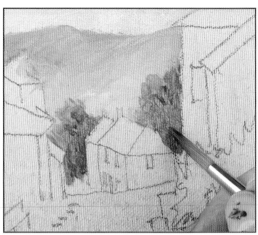

5 Still using the size 18 flat brush, mix Payne's gray with alizarin crimson and add a hint of titanium white. Block in the distant hill. Pick up white on the brush without rinsing it. Use this to blend the bottom of the hill in with the middle distance by softening the colour into the centre. Don't make it perfectly flat and dead; leave a few rougher areas and brushmarks to create a sense of distant detail and life.

6 Change to a size 8 round brush and use a mix of Hooker's green and Naples yellow to drop in the trees that frame the distant building with fairly small, controlled marks. Add a mix of Hooker's green and raw sienna in to add variety.

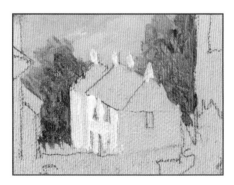
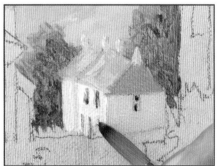
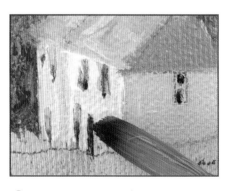

7 Paint the left-hand side of the distant buildings with titanium white, but add cobalt blue to the white for the right-hand sides in shadow. Avoid the windows, leaving them as the pre-stained colour for the mix. Don't forget the chimneys; paint these with the same technique.

8 Use a mix of Payne's gray and titanium white for the roofs in shadow. Add a touch more white to the mix for the left-hand sides of the rooftops – those in the light. Next, paint in the windows using pure Payne's gray. At this distance, they are no more than blocks: a single stroke will suffice for each window.

9 Brightly coloured doors offer a chance to add a bit more interest. Here I am using eye-catching alizarin crimson to draw the viewer's eye down the street.

10 Make a shadow mix of Payne's gray and alizarin crimson. Add this where the roof meets the distant buildings, and within the window. This shadow is important; it adds visual weight and detail. You can also suggest some bushes or similar obscured detail on the shadow side.

11 Now that the hills have dried a little, paint the tops of the hills with Naples yellow, drawing it down from the crest into the sides to suggest shaping and texture.

12 Working forwards, start to paint the buildings on the left-hand side, using the titanium white and cobalt blue mix for the areas in shadow, and titanium white for the areas in light.

13 Use a mix of raw umber and burnt sienna for the roof, then use raw umber on its own for the shaded side of the next building. Add titanium white for the lighter side.

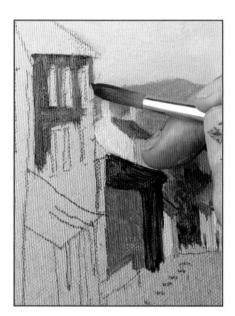

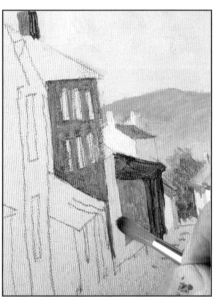

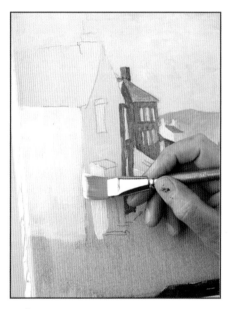

14 Mix Payne's gray and cobalt blue for the roof of this building, then use a mix of raw umber, alizarin crimson and a touch of burnt sienna for the next large building in line. Note that the tones are starting to get stronger as the buildings advance towards the viewer.

15 Mix raw umber and Payne's gray and paint the chimney's shaded side, then add titanium white to the mix and paint the lighter side. Use a mix of titanium white and cobalt blue for the sliver of building between the two, as shown. Use Payne's gray and cobalt blue for the roof here.

16 Block in the remaining buildings on the left with the same techniques and colours. Note that using fairly thin mixes results in the underlying warmth of the pre-stain coming through. For large areas with little detail, like the side of the closest house, feel free to swap to a larger brush – here I am using a size 18 flat.

Tip

Vary the colours of adjacent buildings in your paintings to avoid having two blending into one another.

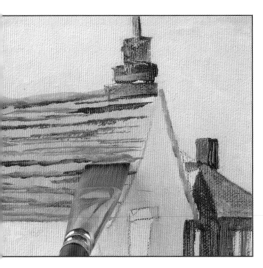

17 Once the walls have been blocked in, start suggesting details on the roof. Use a mix of raw umber and burnt sienna to add broken horizontal lines to the front roof to intimate the impression of tiles.

18 Rather than painting each stone, simply suggest the rocky texture on the foreground building with a few scattered areas of stonework, using short strokes of a Payne's gray with titanium white mix. Use a size 8 round brush and change the pressure you use to vary the size of the strokes.

19 Add more Payne's gray for the stone on the shaded side, then make a mix of Payne's gray and cobalt blue and fill in the panes of glass in the windows with clean strokes. Leave some of the undercolour showing through as the frame. Windows are to a painting of a building as eyes are to a portrait – they add character and seem to bring life to your work.

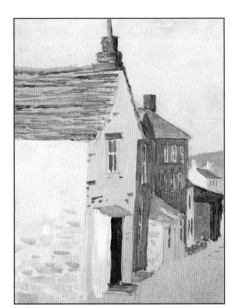

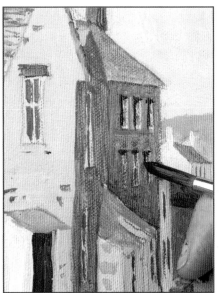

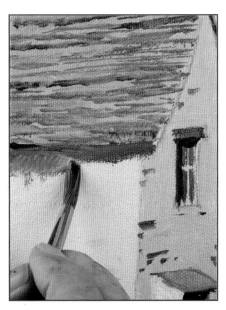

20 Use Naples yellow to add more strokes to both the stonework wall and the roof of the foreground building. This variety of colours helps to prevent the building looking flat and dull.

21 Add the shadows cast by the buildings using a fairly strong mix of Payne's gray and alizarin crimson and the size 8 round brush. Start by adding strokes of the shadow on the top and left-hand side of each window. This sets each window within the wall of the buildings by suggesting a recess.

22 Where the roof of each buildings meets the wall, add a line of shadow. Work back in with a clean damp brush to soften the base of the line, drawing the paint down the wall to prevent the effect being too stark.

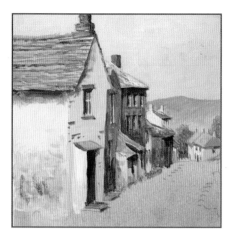

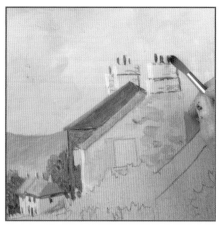

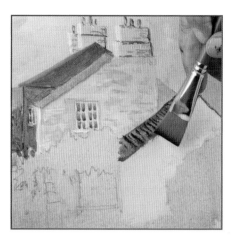

23 Add a few touches of the shadow mix (Payne's gray and alizarin crimson) to the buildings themselves, softening the colour in with a clean damp brush. This helps to suggest age and detail. For darker areas – the slate roof and dark walls – use titanium white to detail instead.

24 Paint the buildings on the other side of the street using the same techniques and the mixes on your palette.

25 When you come to the foreground roof, use the size 18 flat to apply a dilute mix of Payne's gray and cobalt blue, then use the corner of the brush to add broken lines with a stronger mix of the same colours to suggest the tiling. These lines should not be perfectly parallel; you need them to lead the eye in slightly to create the impression of perspective.

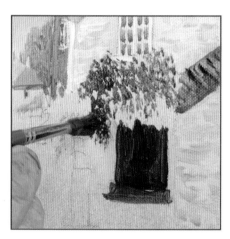

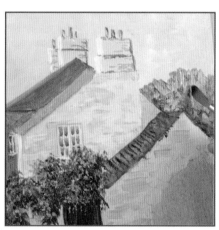

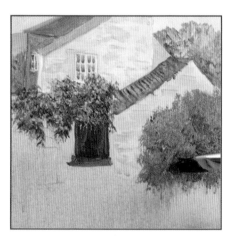

26 For the foliage, split the size 8 round brush by pressing it point-first on to the palette to pick up a very strong mix of Hooker's green and burnt sienna, then stipple the area.

27 Add shadow to the foliage in the same way using Payne's gray, then rinse your brush and add highlights using Naples yellow.

28 Pick up the green mix (Hooker's green and burnt sienna) on the size 18 flat brush, splitting the brush. Build up the foreground foliage with a stippling action of the flat brush. Still using the split brush and stippling techniques, add burnt sienna over the top to vary the hue, then shade and highlight with Payne's gray and Naples yellow in turn.

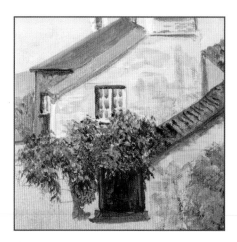

29 Add the shadows to the building with the shadow mix of Payne's gray and alizarin crimson. Keep the shadows consistent across the painting – on this side of the street, the shadows are still applied to the top and left of the windows, for example. Note that the foliage will cast shadows, too.

30 Use the size 18 flat brush to paint the road using a fairly thin mix of raw umber with titanium white. Use sweeping horizontal motions of the brush to avoid the road surface looking unnaturally flat and even. Allow some of the undercolour to show through.

31 In the distance, drop in a little Naples yellow on the path using the blade of the brush. This is very effective at suggesting sunlight and drawing the eyes, but don't go mad – like all such techniques, it is often most effective when applied sparingly.

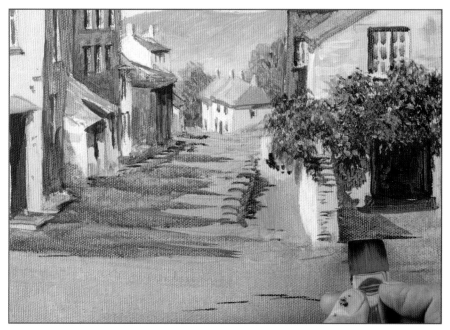

32 With the road in place, you can build up the street furniture like the foreground walls – painted like the buildings – and the cobblestones, by applying Payne's gray to the road surface in short horizontal touches here and there. You can use the corner and side of the size 18 flat to apply the paint.

33 Allow the paint to dry completely, then add the shadows cast by the buildings on to the road. Shadows are just like any other colour used when painting; they are stronger close-up and weaker further away. You can use the same mix all along the path, simply adding more water for the more distant shadows. Vary the length of the shadows according to the height of each building, and don't forget the shadows on the right-hand side of the low wall and beneath the foliage. A shadow cast across the foreground by a building just out of shot helps to frame the image, too, though this is optional.

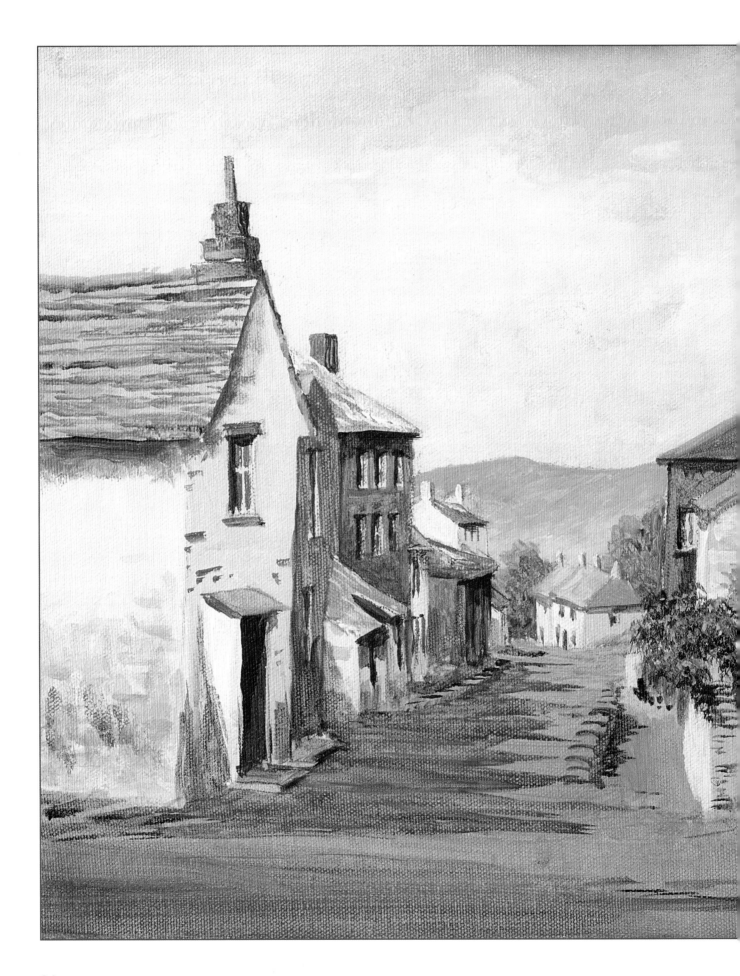

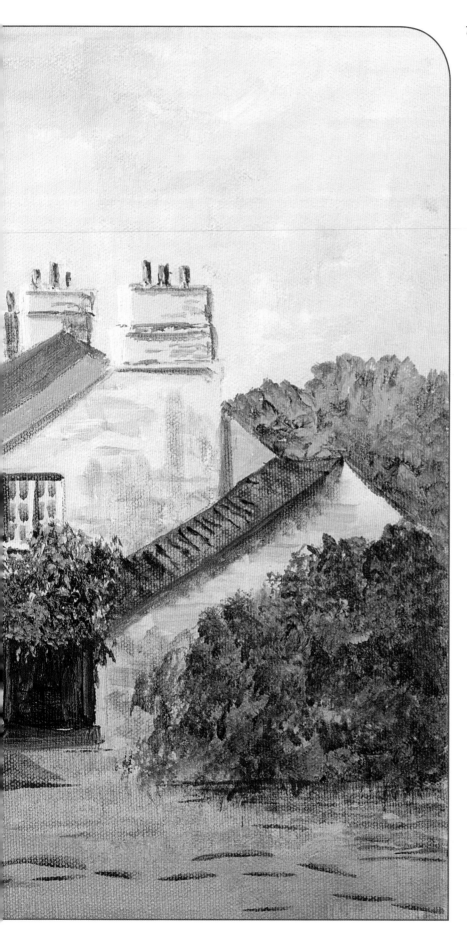

CHARLES.M.EVANS.

Westminster Bridge

An iconic view of London. This looks very detailed, but painting it is really just a matter of identifying strong recognisable shapes.

Painting water

Water is great for adding movement and life to your paintings; and is hugely varied – everything from tiny brooks to the open sea. When painting water, always base it on the same blue as you use in the sky – you will use different depths of the colour, but having the same base hue helps to keep the painting coherent.

Waterfall

Before you begin, paint the surrounding area, leaving a gap for the waterfall. Here I have used the technique from page 86 to add rocky areas, but you could try grassy banks if you prefer.

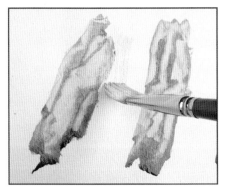

1 Split the size 18 flat brush in a mix of titanium white with a little cobalt blue. Place the brush at the top of the gap and make a very short curve (don't let your curve go upwards at any point!), then begin to draw it vertically downwards.

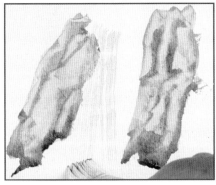

2 Draw the brush straight down to the bottom – that is, the surface of the water below – in a single stroke. Don't worry if the brush runs out of paint – this will simply look like the stream breaking up into droplets.

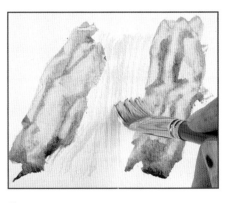

3 Repeat the process to fill the area with light touches. You can vary the angle of the brushstrokes lower down the waterfall – this represents the water cascading over hidden rocks.

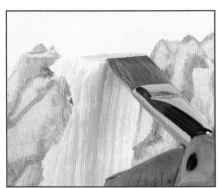

4 Add a few horizontal strokes at the top with the blade of the brush to suggest the water level at the top of the waterfall.

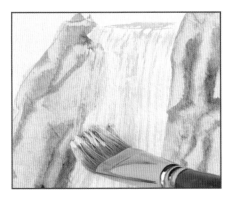

5 Clean the brush and split the bristles as you pick up titanium white, then work this lightly over the waterfall, working from the top downwards to suggest foam – add some extra at the bottom.

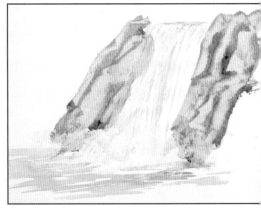

6 To finish, add horizontal strokes of a darker mix of Payne's gray and cobalt blue at the base, leaving a clean white area for the frothy part. Overlay the white gap with heavy stippling around the base of the waterfall to create the foam.

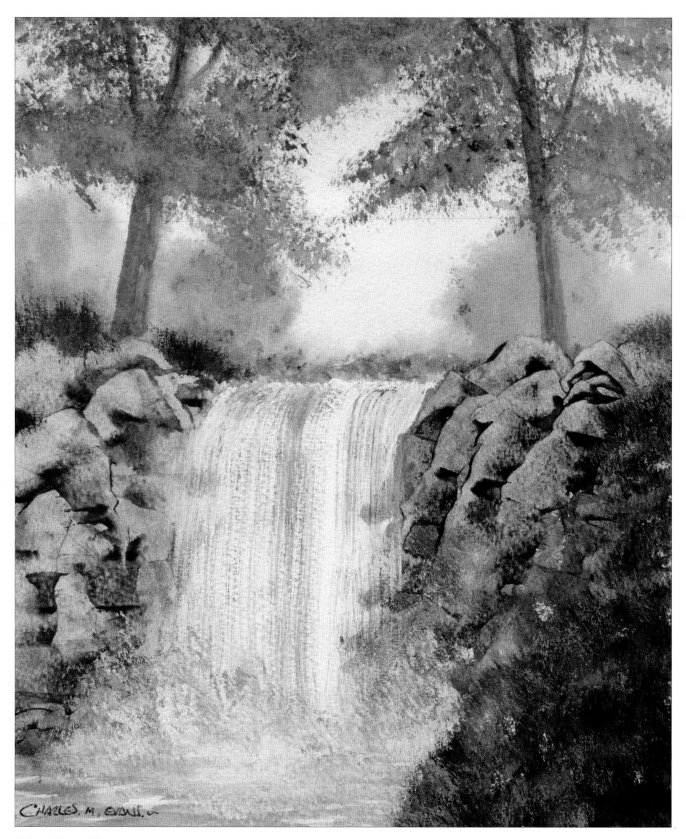

Crisp, Clean Water

This more developed painting uses the technique opposite for the waterfall.

Reflections

It is so easy to make a reflection that looks like it's merely sitting on top of the water, which gives an unrealistic effect. The solution is simply to paint the reflection first, and then, once dry, wash the water over the top of it. This will soften the reflection and make the finished result look more convincing.

This approach works well with acrylics, which dry quickly to become non-watersoluble. As a result, the reflection will not bleed, as it might with watercolour, nor will it smear, as it might with oils.

When painting reflections, try to use the same colours and mixes as you are using for the objects being reflected – so if you are using cobalt blue in the sky, use it for the reflection of the sky too.

One other important point to remember about reflections is that the surface of the water acts as a mirror, so whatever is reflected will be a mirror image of the object – this is, perhaps, obvious in the case of buildings and other detailed shapes, but it is easy to forget when painting trees, resulting in branches that strike out in the wrong direction. It may not appear immediately clear, but something will feel wrong about the result.

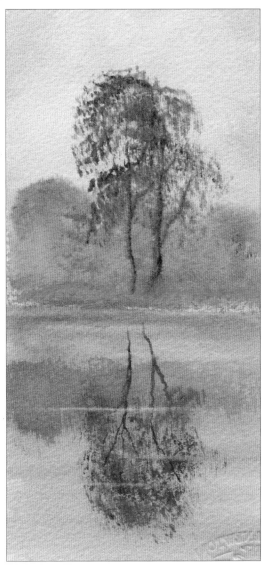

A Summer Pond

A very simple little painting which beautifully sums up how effective reflections can be in adding atmosphere.

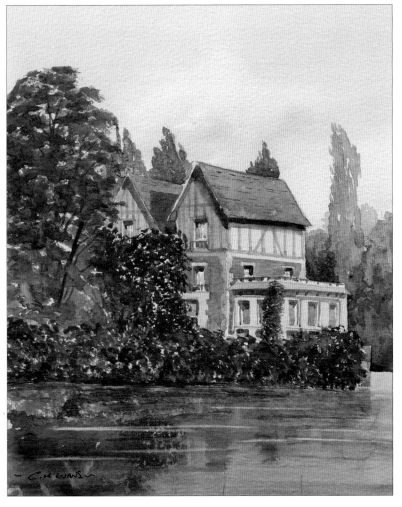

Château Quesmy

A château in France which I have visited many times over the years. This moated building provides endless inspiration for reflections.

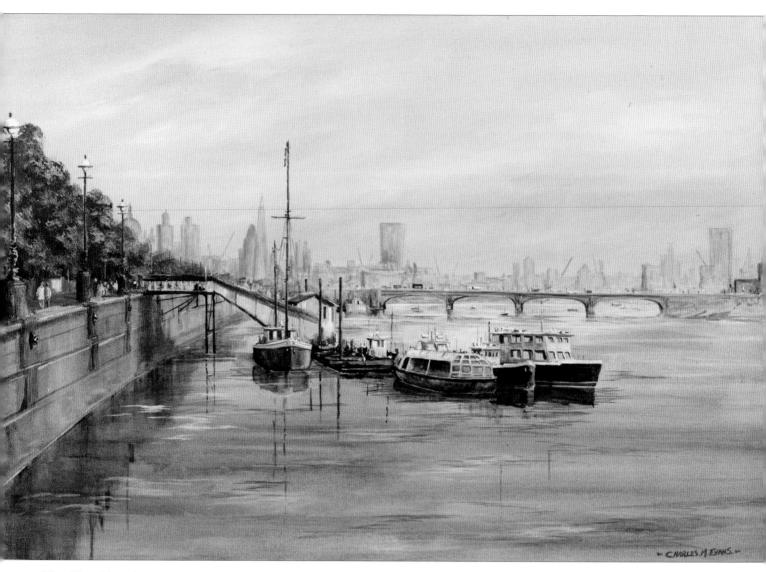

The City of London

The reflections in the foreground water help to add power and a sense of scale to this painting.

Lake

This exercise will walk you through a very simple lake landscape, and provide a few simple lessons in getting reflections right. As mentioned earlier, many people add the reflections on top of the water, which looks wrong when finished. If you add the reflections first, things look a lot more natural.

Keep all the paint fairly watery for the entirety of this painting.

1 Apply a very weak cobalt blue wash for the sky, then suck out a few clouds using a damp size 18 flat brush. Once dried, shape a middle-distance hill with a little weak raw sienna.

2 Using the same brush and colours, repeat the hill shape below the hill, thus starting the reflections. Leave a thin line of clean white paper between the shape and its reflection.

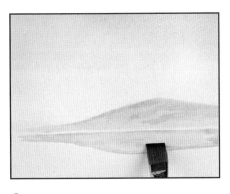

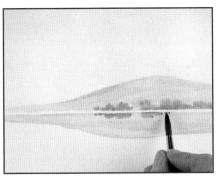

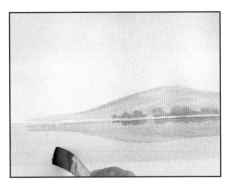

3 Add a little watery cobalt blue to the top of the hill to give it a little shape, then repeat the process in the reflection of the hill, making sure to mirror the shapes in the reflection.

4 Change to the size 8 round brush and use a mixture of Hooker's green and raw sienna to dab on a few distant trees. If this is done whilst the hill is still damp, they will soften slightly giving you a more hazy effect. These are then repeated below for the reflection. Notice a tiny gap between hill and trees and the reflection.

5 Once everything is totally dry, go back to a size 18 flat brush and use a weak wash of cobalt blue to fill in the water area with smooth horizontal strokes. Work right over the reflections, leaving the white line of paper clean.

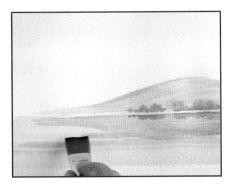

6 Wash and squeeze out the brush and use the blade to lift out a few strips of light on the water to complete this very simple but effective exercise.

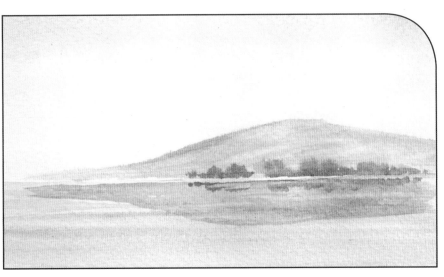

The finished painting.

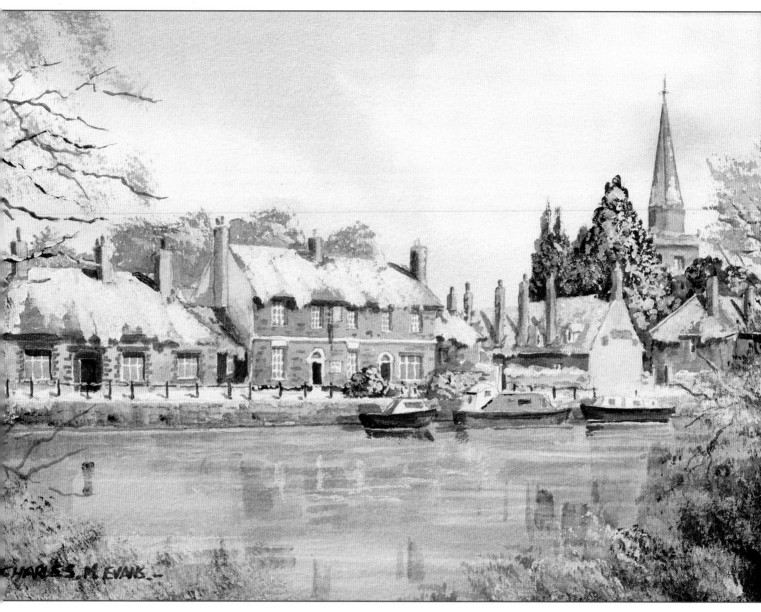

Winter on the River

Notice how the blue within the snow, especially on the trees, helps to capture the light of the snow. The reflections here are very simple strokes of colour, not detailed.

River Walk

This bright and inviting scene combines a lot of the techniques we've looked at on the previous pages: it includes clear skies, trees – both in the background and close-to – and offers a great opportunity to practise painting both fast-moving water in the rapids, and slower water in the main body of the river. It also includes reflections, ripples and the distinctive glittering highlights that make water look effective in a painting.

You will need

300gsm (140lb) Not surface watercolour paper; pencil; water pot; masking tape; plastic card

Colours: cobalt blue, burnt sienna, Hooker's green, raw sienna, Payne's gray, Naples yellow, raw umber

Brushes: size 28 flat, size 18 flat, size 2 round, size 8 round

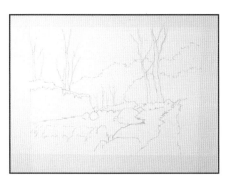

1 Transfer the image to paper, then run masking tape round the image to create a border and secure it to your board.

2 Wet the sky area with plenty of clean water using the size 28 flat brush. Paint the area with cobalt blue and burnt sienna. Work right over all of the trees and foliage.

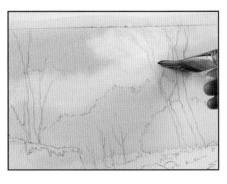

3 Rinse and squeeze excess water from the brush and use it to lift out a few clouds.

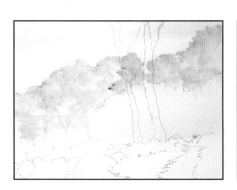

4 Allow the paint to dry until it is just damp. Before it is completely dry build up the distant foliage with a dilute mix of Hooker's green and burnt sienna, applying it with a dabbing motion of the size 18 brush.

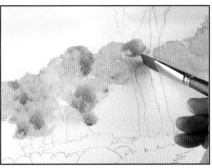

5 Drop in a little raw sienna wet-in-wet to vary the colour of the foliage, then do the same with dilute cobalt blue. This helps to add depth and shape to the greens.

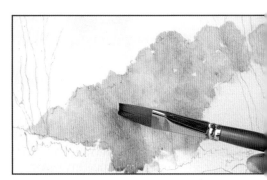

6 Rinse the brush and squeeze out excess water. Tap the damp brush here and there over the area to soften and blend the colours together.

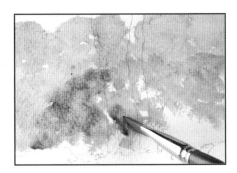 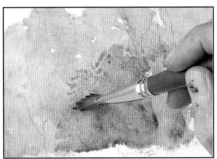 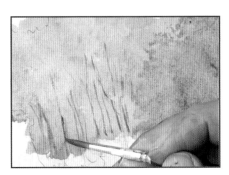

7 While the distant trees remain wet, start to paint the area of midground trees with a less dilute mix of Hooker's green and burnt sienna, adding burnt sienna wet-in-wet. These stronger, warmer colours help to give the impression the area is closer.

8 Add cobalt blue wet-in-wet to the midground trees to add depth to the area, then split the brush and reinforce the area at the top with more of the Hooker's green and burnt sienna mix.

9 Paint some subtle tree trunks in the lower part of the distant foliage, using the tip of the size 2 round brush and a light mix of raw umber with a little Payne's gray.

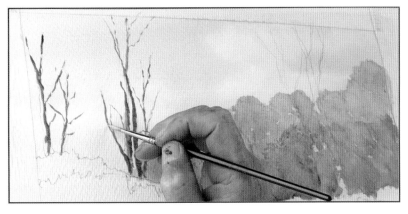 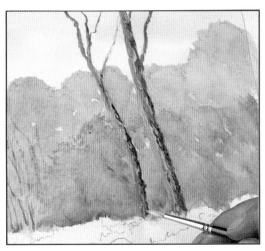

10 While the area you've been working on dries, add more Payne's gray to the mix and add the larger trees on the left-hand side with the size 2 round brush. Use broken lines and add Naples yellow wet-in-wet with the tip of the brush. This can be used to join the broken lines, suggesting shaping on the branches and stopping the tree looking like a silhouette. Favour the left-hand sides of the trees and branches to suggest the light coming from the side.

11 Strengthen the mixes still further and paint the foreground tree in the same way. When adding the Naples yellow, aim to create texture by using slightly broken, shaky lines.

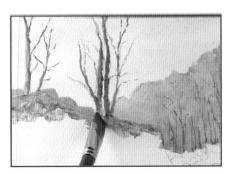 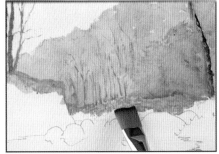 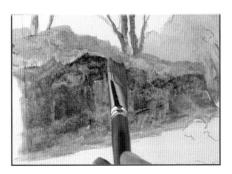

12 Change to the size 18 flat and paint the undergrowth on the top of the bank on the left-hand side using raw sienna, adding Naples yellow wet-in-wet on the very top.

13 Paint the area beneath the distant trees with a brighter green of Hooker's green and Naples yellow, then the dark area of the bank with a mix raw umber and raw sienna. Create fairly sharp edges.

14 Add a little of the Hooker's green mix to the undergrowth on top of the bank, then dilute the dark mix (raw umber and raw sienna) and paint the area beneath the central green area.

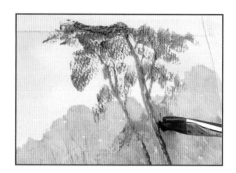 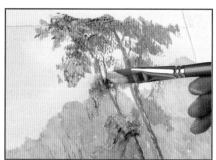 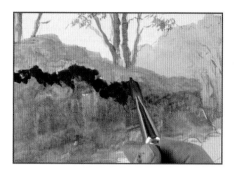

15 Holding the size 18 flat brush sideways to achieve a rough edge, add foliage to the larger trees using taps of a strong green mix of Hooker's green and burnt sienna. Use smaller touches for the trees on the left-hand side, building up the foliage in the same way.

16 Add shading and texture with dabs of fairly strong Payne's gray followed by Naples yellow, each added wet-in-wet.

17 Using the size 18 flat with a mix of Payne's gray, cobalt blue and alizarin crimson, add the darkest shadows where the soil of the bank meets the undergrowth on top.

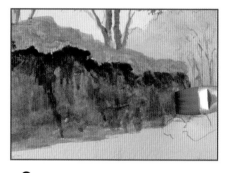 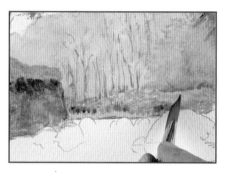 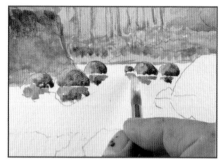

18 Soften the colour in with a damp brush, then use the same mix to suggest near-vertical broken marks in the bank, using the blade of the brush to achieve fine lines.

19 Dilute the mix a little further and use the corner of the brush to do the same for the distant bank in the centre of the image.

20 The rocks in the distance can be treated fairly loosely. Start off by applying raw umber to each rock with the size 8 round brush, then add fine lines beneath each one as rippling reflections.

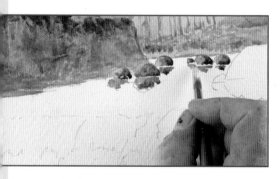 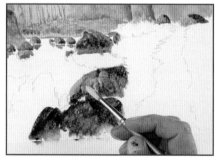

21 Add Payne's gray to the rocks and reflections wet-in-wet, then add highlights to the left-hand sides of the mix with a mix of Naples yellow and titanium white.

22 Use stronger tones of the same mixes (add more paint so they are less dilute) for the midground rocks on the bank; then paint the foreground rocks with fairly strong raw umber followed by Payne's gray, followed in turn by Naples yellow.

23 Use the corner of a plastic card to scrape across the foreground rocks to add detail to them, as described on page 86. Allow the painting to dry before continuing.

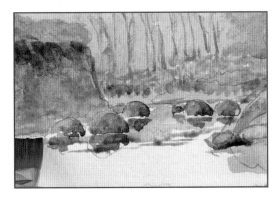

24 Starting from the distance, start to paint in the river with small strokes of a cobalt blue and Payne's gray mix, holding the blade of the size 18 brush horizontal. Leave a few fine lines of white paper as bright, rippling highlights, but paint right over the reflections of the rocks.

25 Continue working down to the waterfall, leaving more and more white space. Split the brush when loading it with the same water mix, then draw it in very light curving marks over the waterfall. Add a little more cobalt blue to darken the mix, then start to paint the swirling water below the waterfall with broken horizontal strokes and leaving plenty of white paper showing.

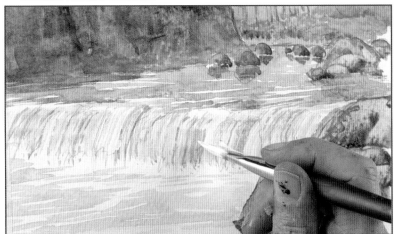

26 Add a few darker touches to the waterfall with the darker mix, using the same light, curved brushstrokes as before.

27 Using the same colour, add some short horizontal strokes across the water upstream from the waterfall with the same mix. Wash the brush out thoroughly and pick up pure titanium white, splitting the brush. Use this to build up the waterfall a little more.

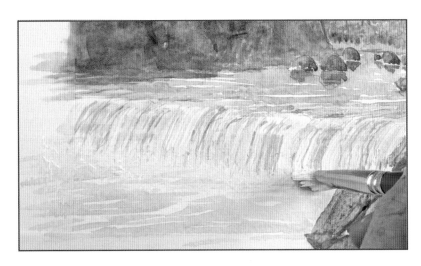

28 For the frothing foam at the base of the waterfall, use a stippling motion to apply more pure titanium white.

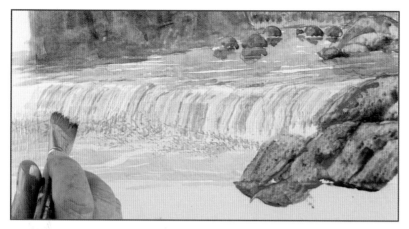

29 Add Payne's gray to the titanium white and repeat the process to build up depth in the foaming waterfall.

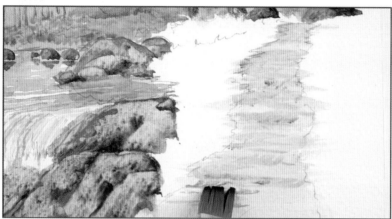

30 Holding the blade of the size 18 brush horizontally, paint in the foreground path with dilute raw sienna, then add touches of burnt sienna wet-in-wet for texture.

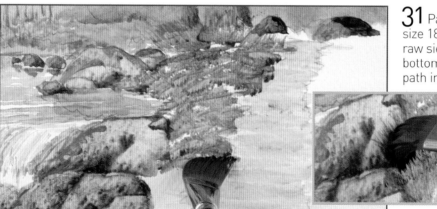

31 Paint the grass in the foreground with the size 18 flat and a mix of Hooker's green and raw sienna, flicking the paint upwards over the bottom of the rocks (see inset), and across the path in the foreground.

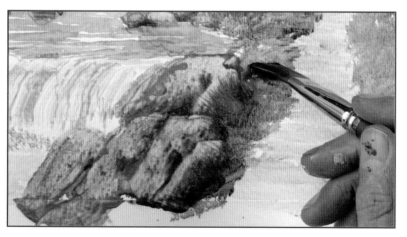

32 With the grass area filled, work back into it with a mix of Hooker's green and burnt sienna to add depth.

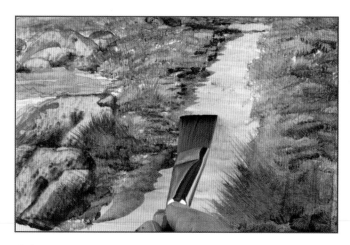

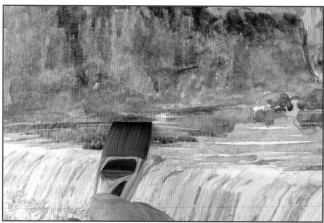

33 Using a shadow mix of Payne's gray and cobalt blue, add shadows cast onto the left-hand-side of the path by the grasses and trees, applying the paint with the blade and corner of the size 18 flat.

34 Strengthen where the bank meets the water using the same brush and mix to finish.

The finished painting.

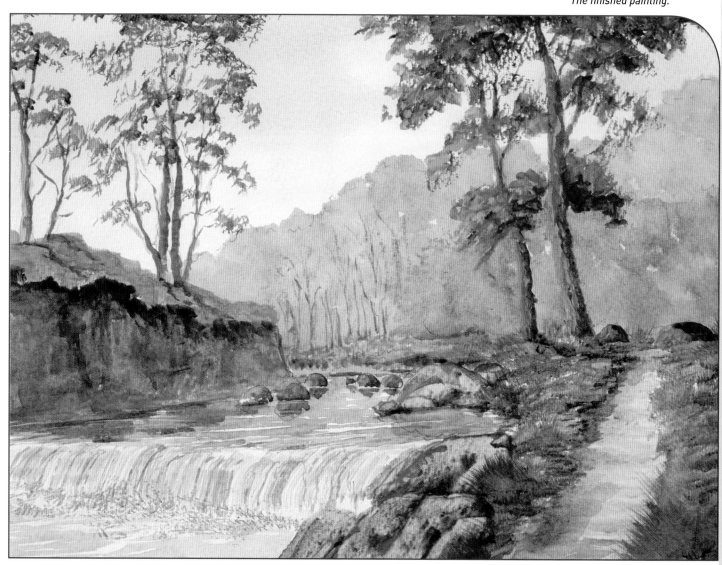

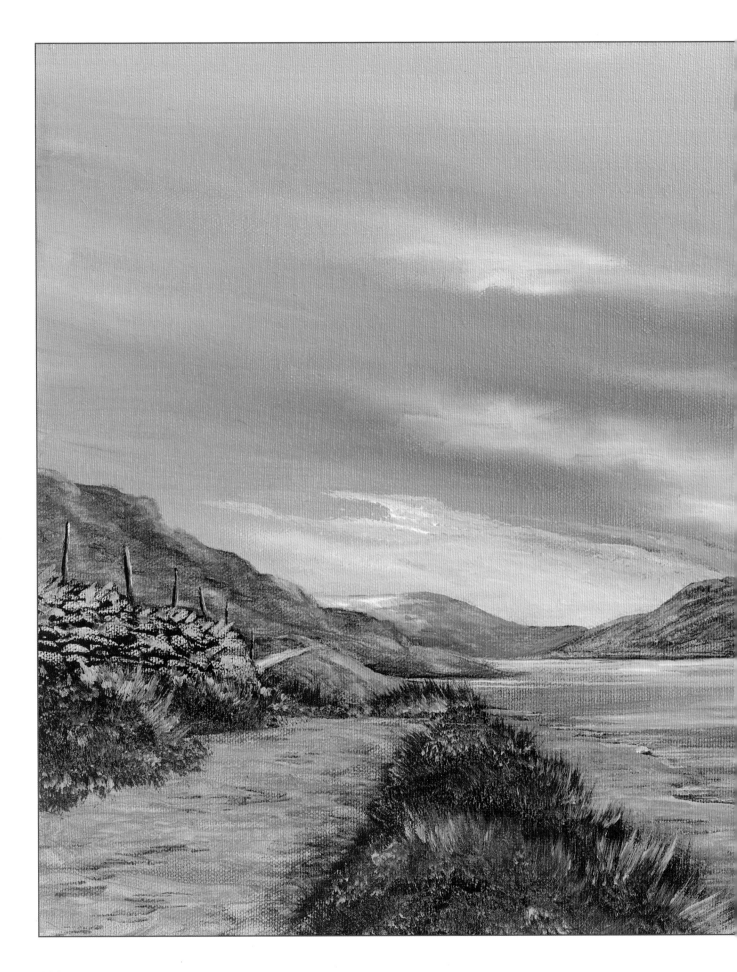

Highland Loch

A big sky reflected in the water.

Painting animals

Like people, animals are great to add to landscapes to create a sense of scale and to add some life and interest. They are also a fun and enjoyable challenge to paint as the main part of your picture. Of course, there are more animals to paint than would possibly fit in this book, so the following pages concentrate on techniques that will help you tackle any animal you want.

Highlights, shades and midtones

One thing that all animals have in common is the way that light falls on them, revealing their shape. This can help you work out the form and structure of the animal, which helps you break down a complex form into something that is easy to paint.

In simple terms, areas where the light hits the animal directly will be brighter. We call these highlights. Those that are hidden from the light are in shadow, and we call these shades. The other areas are midtones. Once you have identified these areas, you can create three mixes: one light in tone, one dark in tone, and one in between. It's then simply a case of applying the appropriate tone within the basic shape of the animal. If you can do this accurately, then the form of the animal will appear in front of you.

Of course, this is a very simplified approach, but it is a valuable one in teaching you to look for the highlights and shades across an animal as a whole, rather than trying to paint the parts – limbs, head and so forth – which can lead to mistakes.

This detail of the left-hand horse's body shows the areas of highlight, midtone and shade clearly. Even when we look so closely that the area appears almost abstract, the tonal work here helps to make sense of the shape.

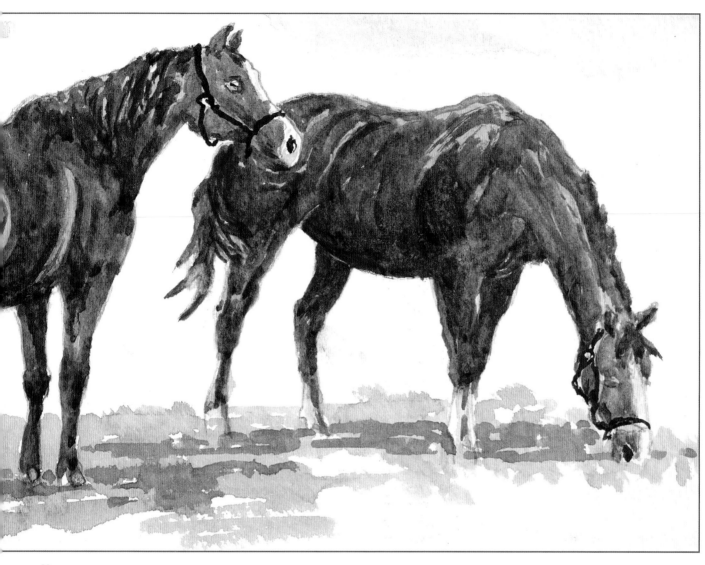

Horses

An intimate little painting of horses at ease.

Painting fur: spaniel

This exercise will let you practise painting a short-haired dog with different colours on its fur. This is useful for two reasons – it teaches you how to deal with shading and highlighting white fur, and it's a good reminder that furry doesn't necessarily mean heavily textured.

As described on the previous page, to suggest the form and musculature of this dog breed, we need to paint in the highlights, shades and midtones. However, when painting white, you need to keep all of the tones very light, even the shades. We use a very pale blue for the shadows, leave the highlights as the white of the paper, and use a pale yellow for the midtones.

1 Start by adding shade to the white fur, using very dilute cobalt blue and the size 4 round brush. Be careful not to overdo this stage; even the deepest shadows should still be fairly light.

2 Continue adding the blue, building it up gradually. Follow the shape of the animal's musculature, not just the outline.

3 To prevent the dog looking too cold and blue, introduce heavily-diluted raw sienna for the midtones.

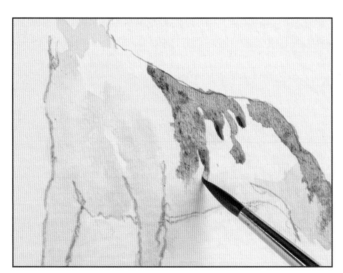

4 With the areas of white fur completed, you can now build up the darker markings using burnt sienna.

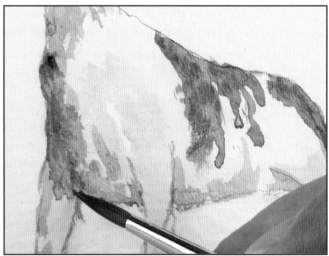

5 Once the darker markings are dry, you can adjust the tone. Try adding more dilute cobalt blue over the top to deepen both the white and brown areas of the fur.

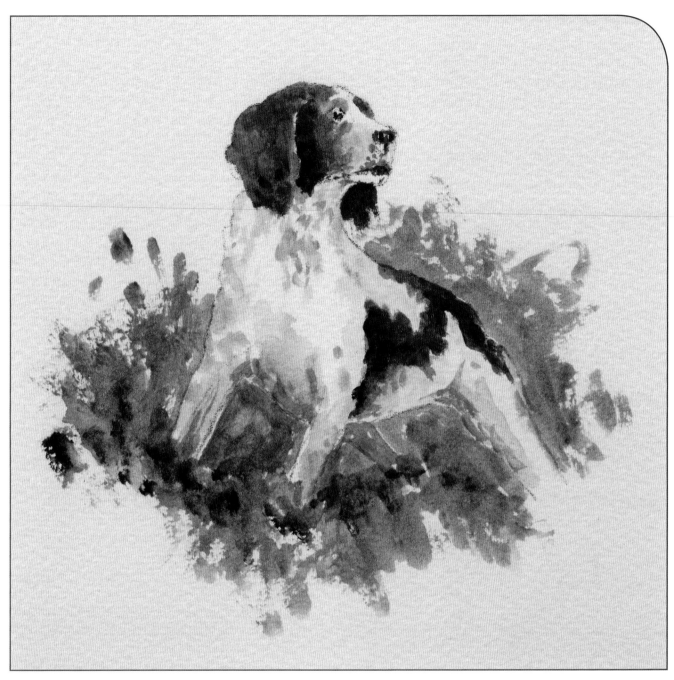

Cocker Spaniel

With quick brushstrokes in the grasses, I tried to create a little excitement and movement in the subject.

Animals in context

Animals are often muted in colour. This is useful in nature when avoiding predators, but not so useful to the animal artist, who wants the focal point to stand out. We have to balance getting the animal to stand out from its surroundings with making sure that it still looks as it should.

The painting on these pages shows one way of approaching this – by combining watercolour-style and oil-style techniques in the same painting. This enables me to have a blurred background against which the crisper, more detailed deer stands out. The contrast in technique helps to make up for the natural camouflage of the deer, without making it artificially obvious.

When using this approach, start from the background – leaving space for the animal – and work forward, gradually using stronger, less dilute paint.

The background was painted first. It is just a mass of varied blues and greens, which combine to suggest texture and distance. Blue is a wonderful colour for this.

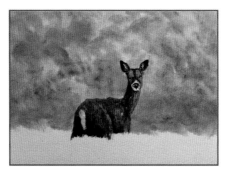

The deer itself was painted next, using good strong mixes of raw umber combined with Payne's gray; raw umber with burnt sienna; and pure Payne's gray for details.

Spotted in the Undergrowth

To finish, a mass of strong foreground grasses were added using mixtures of Hooker's green and burnt sienna; Hooker's green and raw sienna; and pure raw sienna here and there for light. This provided a strong foreground without taking away from the main subject.

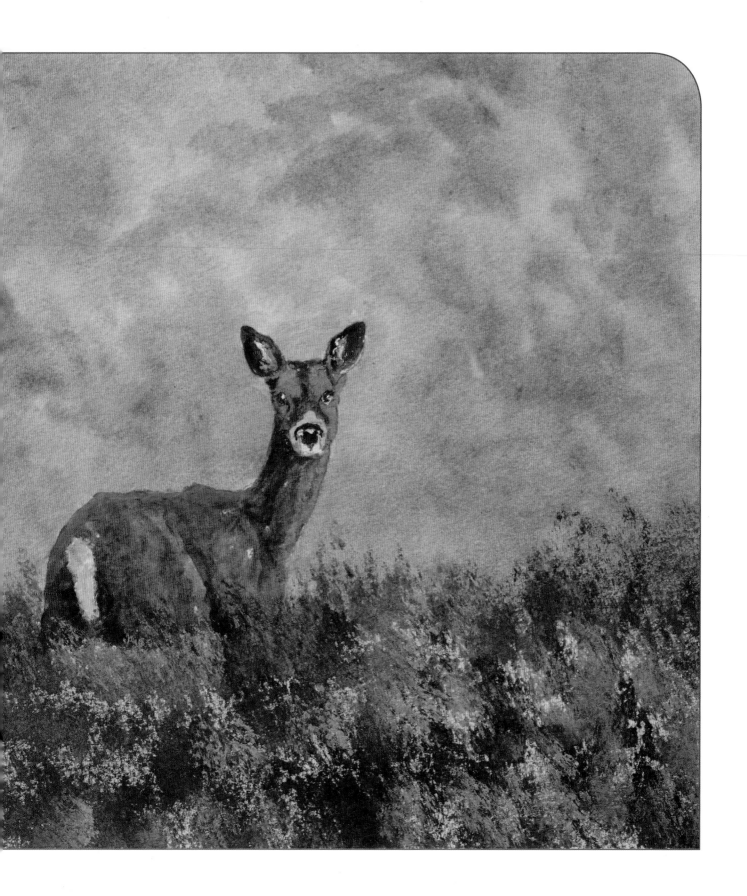

Ride in the Snow

As a horse rider of many years, I love the creatures and know their shapes well. When you have empathy with the subject it makes it much more pleasurable to paint. This little snow scene reminds me of so many winter rides.

It is also an ideal exercise with which to end the book, as it combines elements from all through the book. Once you have finished, look back through and you will see how far you have come!

Outline 11

You will need

Primed 100 per cent cotton canvas; pencil; water pot; masking tape

Colours: raw sienna, cobalt blue, titanium white, Payne's gray, raw umber, Naples yellow, burnt sienna, alizarin crimson, Hooker's green

Brushes: size 28 flat, size 18 flat, size 8 round, size 4 round

1 Transfer the image to the surface, then pre-stain the painting with very dilute raw sienna and the size 28 brush. Allow this to dry before continuing.

2 Make a weak mix of cobalt blue and titanium white for the sky. Use a size 28 flat to paint from the top of the canvas down.

3 As you work towards the horizon, add more titanium white. Use the edge and corner of the brush to cut in around the figures.

4 Once you have filled the sky, add more titanium white to the sky mix and add in rough shapes for the clouds. Use a light rolling motion of your fingertips to smooth in the clouds a little. Note how the undercolour shines through the weak wash as you smooth in the paint.

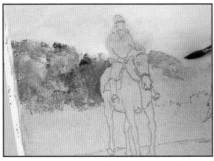

5 Mix Payne's gray with cobalt blue and load the size 8 round brush. Place the side of the brush on the surface and drag it lightly downwards to create the impression of broken foliage in the background. Alter the proportions of the paints in the mix to vary the tone, and work carefully around the figure.

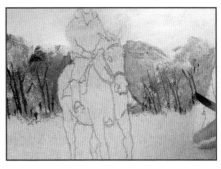

6 Work all the way across, then, using Payne's gray on its own, add a few strokes to suggest the trunks and main branches of trees in the background. Add these sparingly – no need to go mad!

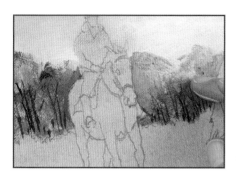

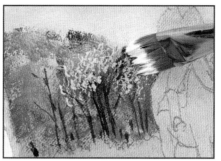

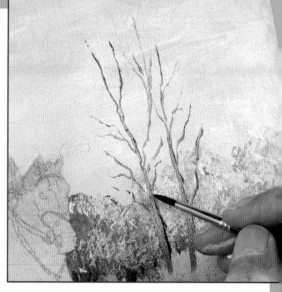

7 Use the tip of a clean finger to soften the tops of the trees a little.

8 Add some snow to the treetops using titanium white with a split brush and stippling motion.

Tip

Be rough with the brush when splitting it, but keep your touch light on the canvas; otherwise you will spoil the stippling effect.

9 With a mix of Payne's gray and raw umber, establish the large foreground tree on the right-hand side. Work from the tip of the branch downwards using the tip of the size 4 round brush.

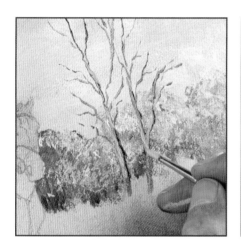

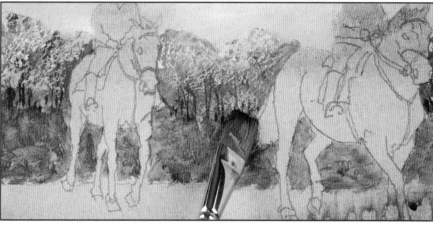

10 Add some Naples yellow highlights, concentrating on the left-hand side. This will establish some form and modelling on the tree.

11 We now move to the middle distance. Switch to the size 18 flat and pick up some raw sienna. Use this to establish the rough undergrowth by twisting and turning the brush to create texture. Work carefully around the figures, using the blade and corner of the brush for smaller, tighter areas.

12 Add burnt sienna wet-in-wet to create variety in the texture of the undergrowth. Use a stippling motion to create the impression of detail; then repeat the process with Payne's gray.

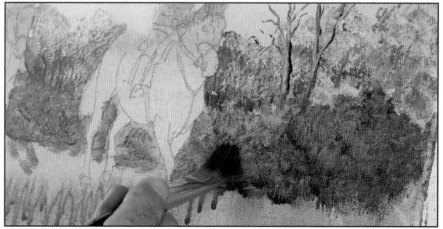

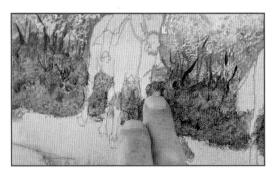

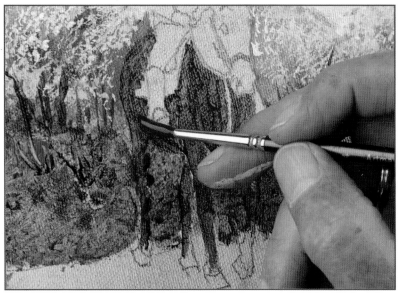

13 To stop the midground looking too chaotic, we now add some individual branches to provide the eye with points on which to rest – use the tip of the size 4 round brush to add occasional short branches into the hedgerow with Payne's gray. Soften the base of the branches – that is, where they emerge from the bulk of the hedge – with the tip of your finger.

14 Using the size 4 round brush, begin to paint the left-hand horse – the bay – using burnt umber. Don't lay on a flat wash. You need to start building up the animal from the very start. Create the shape of the animal with your brushstrokes – following the curves and using smooth strokes for larger areas of bulk. For instance, the belly is curved. Stay aware of your underlying pencil marks.

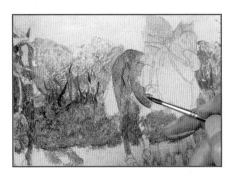

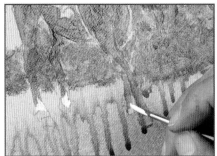

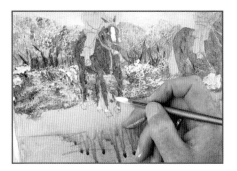

15 Paint the right-hand horse – the red – with a mix of raw umber and burnt sienna. Build up a base layer of colour on the horse in the same way. These foreground details require you to spend a little more time than the broader details of the background, but enjoy the flow of the painting.

16 Use pure titanium white to add details like the stars to the horses' heads, and the feathers around the feet. These details establish the lightest tones on the horses. While the paint on the horses dries, you can return to the midground, which will have dried sufficiently.

17 Using pure titanium white, the size 18 flat brush and a stippling motion, add the snow to the midground. Change to the size 4 round brush to add the snow on the hedges visible between the horses' legs.

18 Repeat the process with a very light mix of titanium white with a hint of cobalt blue, concentrating on the lower areas of the hedgerow.

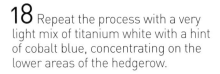

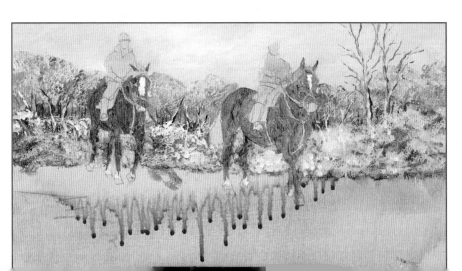

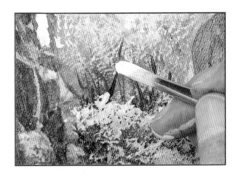

19 Add some sparing fine highlights to the larger branches with the tip of the brush and titanium white.

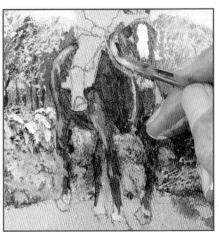

20 Change to the size 8 round brush. Add titanium white to raw umber and establish some light strokes on the bay horse, starting on the flanks. There's no need to be anatomically perfect, but think about the shape and musculature of the horse and add these highlights where appropriate – this will tend to be on the upper and left parts of the horse.

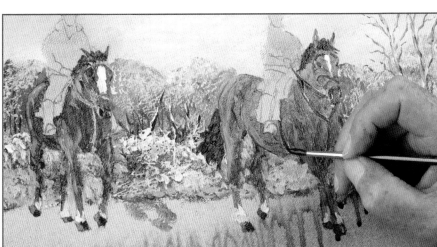

21 Add highlights to the red horse in the same way; using a mix of titanium white, raw umber and burnt sienna – you can add the white to the existing mix on the palette. Use a mix of Payne's gray with raw umber to make a dark mix for the horses' hooves, applying the paint with the tip of the size 8. Overlay pure Payne's gray on the right-hand sides for shading.

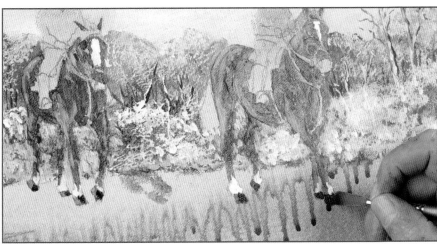

22 Use the size 4 round to paint the manes, tails and other dark details – the eyes, noses and so forth with a black mix of Payne's gray and burnt sienna. Add raw umber to the mix for the tack (the harness, reins, and saddle). Leave a few gaps of the undercolour showing through to prevent these dark areas looking flat.

Tip

Never buy manufactured black. It appears flat and lifeless – I think it looks horrible. Instead, make your own rich, lively black with a mix of equal quantities of Payne's gray and burnt sienna, as here.

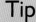

23 Still using the size 4 round, paint the rugs on the saddles. Use a pink mix of titanium white, raw umber, burnt sienna and alizarin crimson for the red's rug, and pure titanium white for the bay.

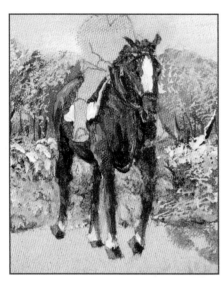

24 Still using the size 4 round and rich black mix (Payne's gray and burnt sienna), establish the darks on the bay. As before, pay attention to the shapes of the musculature and use your brushstrokes to help reinforce the shapes of the horses.

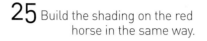

25 Build the shading on the red horse in the same way.

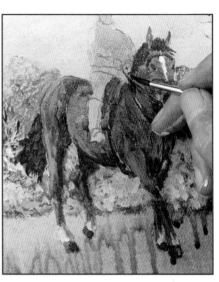

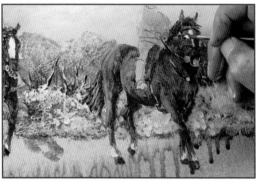

26 Still using the size 4 round, lift the tack with some titanium white highlights to suggest rings and similar fastenings. Use the tip of the brush to add highlights on the manes and tail, then a small dot for a highlight in the eye. Make sure to place it off-centre to avoid a staring effect.

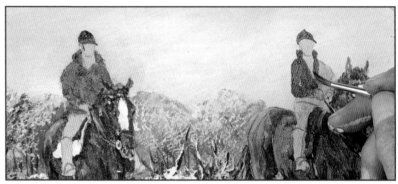

27 Add touches of alizarin crimson and Naples yellow to titanium white and paint the skin of the riders, then paint the helmets of the riders with a touch of the black mix (Payne's gray and burnt sienna). You can paint the jackets of the riders as you wish – I have used a Hooker's green and burnt sienna mix for the bay rider and alizarin crimson for the red rider.

28 Mix Naples yellow with titanium white for the jodhpurs, and use pure titanium white for their shirts. For the boots, use the black mix. Don't miss the tip of the boot visible on the far side of the bay!

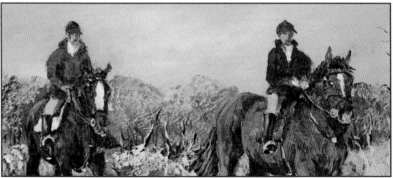

29 Create a warm shadow mix by adding a little alizarin crimson to Payne's gray and use this to add shadows to the figures. When painting the faces, don't get caught up in trying to create a perfect likeness. Instead start with the shadow of the hat brim cast on the face, then pull this colour out to hint at the shadow of the eyes and other features. To finish the riders, add stripes of titanium white for the stirrups and for highlights on the shiny leather boots.

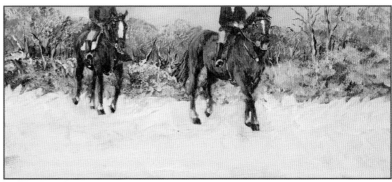

30 Using the sharp corner of the size 18 flat brush, carefully paint around the horses' feet with strong titanium white (pick it up with a damp brush, but don't add any water). Use a dabbing motion away from the feet to build up larger areas.

31 Once the areas near the horse are painted in, you can use big bold strokes to cover the remainder of the foreground

Tip

To avoid a sharp edge between the foreground and midground hedge, use the edge of your brush to add varied light strokes to suggest grasses and breaks in the hedgerow.

32 To further emphasise the softness of the snow as it disappears into the hedgerow, tap a clean fingertip along the edge.

33 Gradually adding more cobalt blue to the titanium white, begin to suggest the shape of the snow. Vary the amount of blue in the mix and build up texture in the foreground. Although the paint is fairly thick, some of the undercolour will still show through.

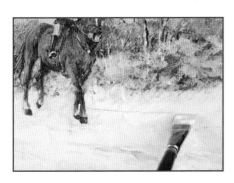

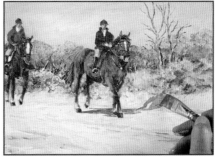

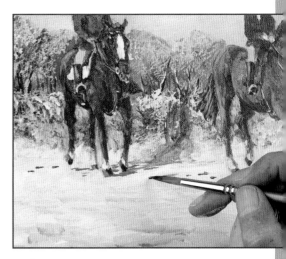

34 Referring to the direction in which the horses are walking, and using their feet as a reference point, use the blue-white mixes to suggest the path by adding some lines and strokes.

35 Make a darker mix of Payne's gray, cobalt blue and little titanium white for the shadows on the snow, including those cast by the horses. Follow the shape of the bank as you add the paint to the ground.

36 To finish, add a trail of hoofprints behind the horses using the tip of the size 8 round and the dark shadow mix.

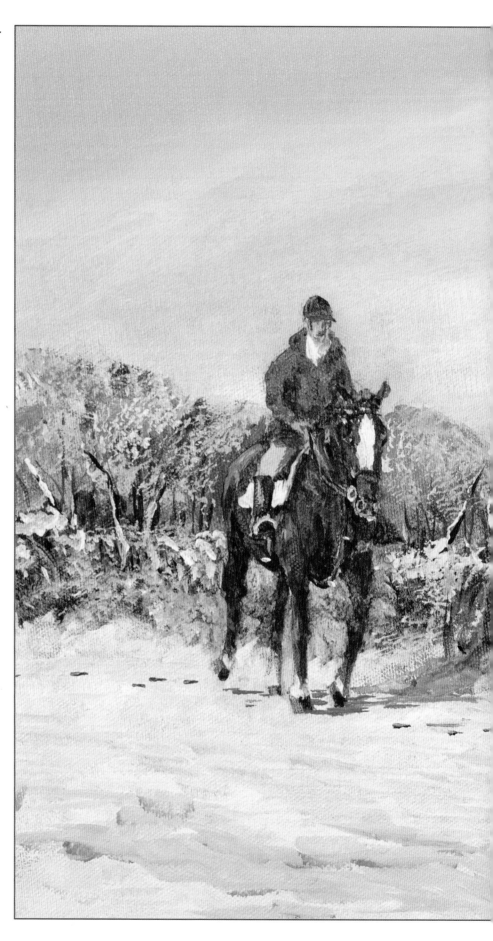

The finished painting.

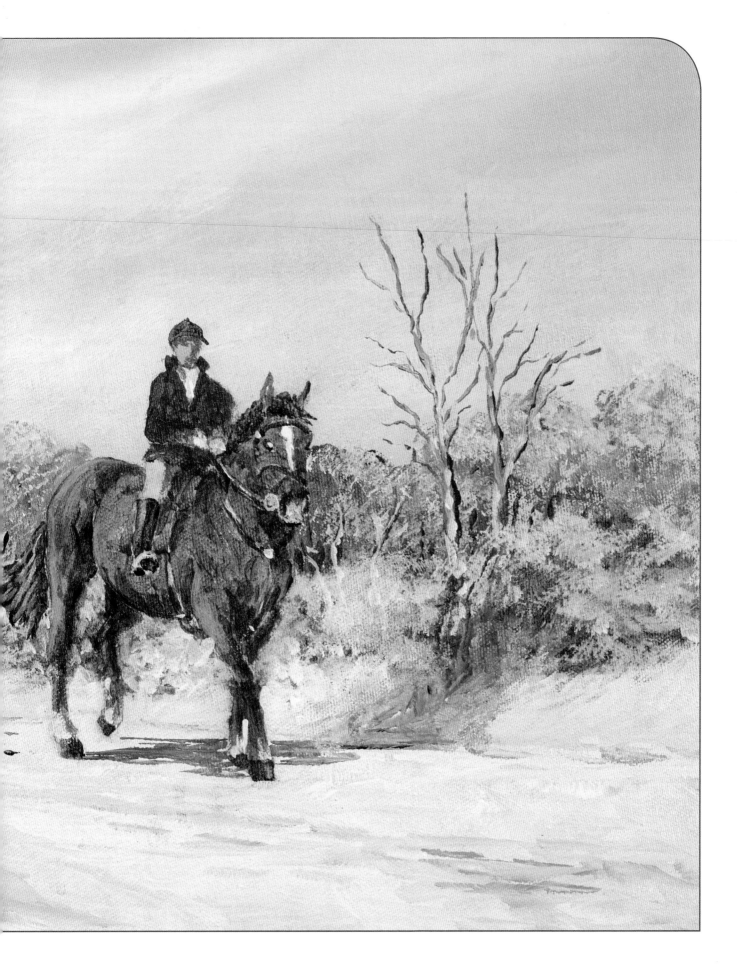

Family Gathering

*Living in rural Northumberland, watching excitable young roe deer
leap around like spring lambs is a scene with which I am very familiar.*

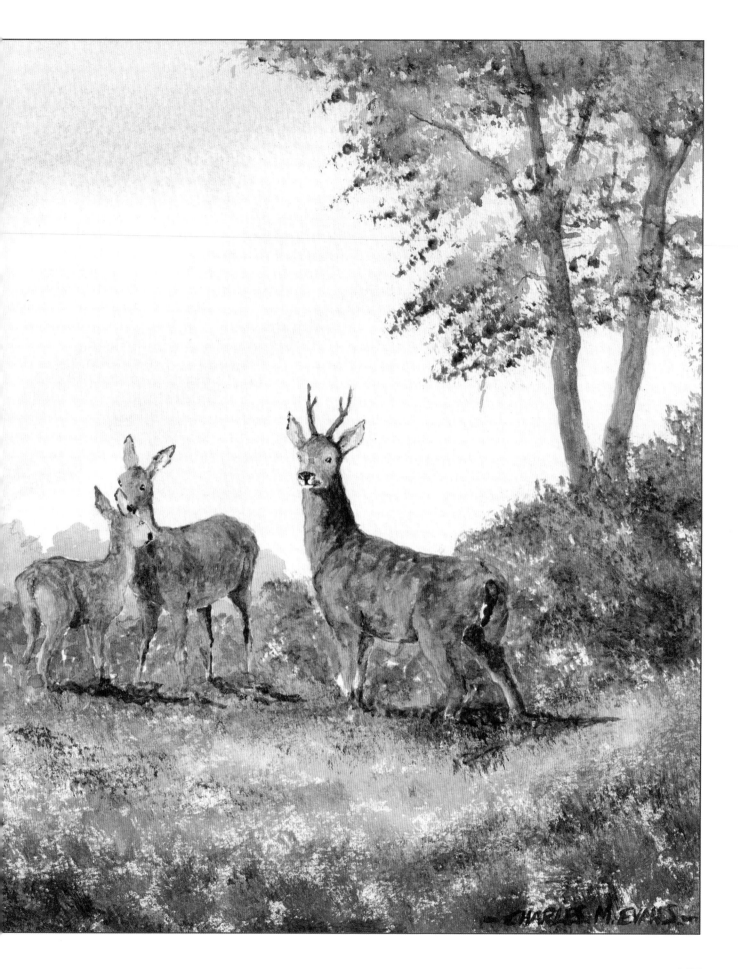

Index